INDUSTRIAL LOCOMO

&

RAILWAYS OF WALES

Gordon Edgar

AMBERLEY

Right: The loco shed at Mountain Ash on 7 September 1979 sees Robert Stephenson & Hawthorns Austerity 0-6-0 saddle tank (W/No. 7139 of 1944) moving off to take up its duties on the NCB's Mountain Ash system. (Author)

Front cover: Sunrise at the heritage Pontypool & Blaenavon Railway on 12 January 2008; after treacherous icy rain and a light dusting of overnight snow, the former NCB 0-6-0 saddle tank (originally Port Talbot Railway No. 813) moves off the Big Pit colliery branch, joining the former L&NWR Brynmawr and Blaenavon line. It was masquerading as sister No. 816 which, up until around 1954, had seen NCB service in the same valley further south at Talywain. (Author)

Back cover: The surface stockyard and sawmill system at Cwm colliery had the most unusual gauge of 2 ft 9½ in. On 24 August 1970, this Frank Hibberd 50 hp Planet four-wheel diesel-mechanical (W/No. 3735 of 1955) was in use. Supplied new, it was scrapped on site, shortly after the colliery was closed in November 1986. (Roy Burt)

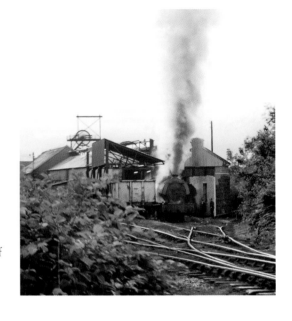

First published 2020

Amberley Publishing
The Hill, Stroud
Gloucestershire, GL5 4EP

www.amberley-books.com

Copyright © Gordon Edgar, 2020

The right of Gordon Edgar to be identified as the Author of this work has been asserted in accordance with the Copyrights, Designs and Patents Act 1988.

ISBN 978 1 4456 4944 3 (paperback)
ISBN 978 1 4456 4945 0 (ebook)

British Library Cataloguing in Publication Data.
A catalogue record for this book is available from the British Library.

Typeset in 10pt on 12pt Sabon LT Std.
Origination by Amberley Publishing.
Printed in the UK.

CONTENTS

INTRODUCTION & ACKNOWLEDGEMENTS

In this, the tenth book in the series taking a look at the industrial locomotives and railways of England, Scotland and Wales, we have reached the end of the 'journey', one where we have been reviewing some of the industrial railways of mainland Britain and the rich variety of locomotives and systems that could have be seen during the last fifty years or so. Fittingly, we conclude this photographic review by looking at a broad cross-section of such railways in the Principality of Wales. The working steam locomotive in industry was a magnetic draw for railfans, especially after the demise of British main line steam in 1968. The final fires were not thrown out of many of the surviving NCB steam locomotives in Wales until the late 1970s, thereby offering a window of opportunity lasting for more than ten years for 'steam-starved' enthusiasts. Quite remarkably, Marine Colliery retained its Peckett saddle tank for even longer, maintaining it as a standby to the resident diesel locomotive until as late as 1985.

Although a small part of a much broader picture, the industrial railways in Wales had a crucial role to play in the commercial industrial supply chains, be it slate for roofing, cement and stone for construction, munitions for military training or possible conflict, coal for power stations or for domestic use and steel manufacture; examples of these industries are featured herein. It is a sobering fact that today, a mere six locations featured in this book still use some form of shunting locomotive on their internal railway system or exchange sidings. Of course, it is not all doom and gloom and the largest collective fleet of commercial industrial shunting locomotives anywhere in Britain can be found at the Port Talbot integrated iron and steel works at Margam.

The compilation of this series has presented some mixed emotions; on the one hand it has provided a nostalgic look back at some familiar places that I had the privilege of visiting at a younger age, when visits to industrial sites were more freely available and in a more relaxed environment than one would experience today. Without exception, I always found the railway and works staff friendly and immensely proud of the part that they had to play in the industries in which they served. The camaraderie in the workplace was all too evident, despite many working in filthy and challenging conditions entirely at odds with those of today. The other aspect of this 'journey' has been one of highlighting just how much has been lost since the 1960s, a time when it was just impossible to experience everything that was there to be seen and photographed. The wholesale decimation of our coal mining industry and the loss of so many steelmaking and engineering plants, along with the livelihood of the many who worked in those industries, is arguably no more evident in any part of Britain than it is in Wales. From the pits in the valleys of South Wales and around Wrexham to

the steel plants and the numerous blast furnaces that they fuelled, what we see today is an entirely different picture compared to that of just a few decades ago. Nature has healed, or is still in the process of healing, those scars made by human activity over the last two centuries or so, and the scene in the future will be even further removed from what has been photographically recorded and depicted in this book.

The heart of the industrial revolution in Wales was at Blaenavon, where coal, ironstone and iron ore provided the necessary ingredients to fuel those industries. It is therefore fitting that this area is now a UNESCO World Heritage Site. Its landscape includes protected or listed monuments of the former industrial processes. The Big Pit Museum and the Pontypool & Blaenavon Railway are key elements to recording the history of this region's past.

It has proved to be a challenge to cover all aspects of the subject within the available space constraints of this book, so I have refrained from including lengthy introductions to the chapters, instead using extended captions to accompany the photographs where space permits. The broad scale of the coal mining industry in Wales is reflected in the number of pages within this book, quite rightly devoted to those NCB systems which were frequently visited during the final years of steam traction.

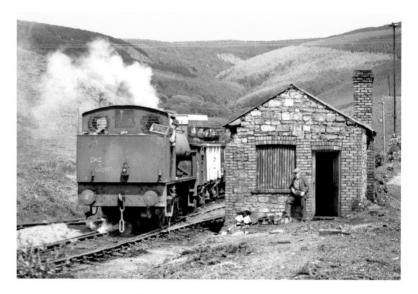

Above: On 5 May 1975, Hunslet Austerity 0-6-0 saddle tank *Pamela* (W/No. 3840 of 1956), with the inscription 'Dai is Great' chalked on her bunker, positions loaded wagons over the weighbridge at Cwmdu colliery (also known as St John's) before taking them down the valley to the Maesteg washery. (Author)

In compiling this book, I have consulted some excellent articles produced by Adrian Booth, Steven Oakden and Tom Heavyside, to whom I am indebted. I would also like to record my thanks to Roy Burt, Tony Brown, John Brooks, John Sloane, Richard Stevens, Kevin Lane, Jon Marsh, Colourail and the Industrial Railway Society for making historic material available from their collections and archives. Without such support, this book would have been impossible to produce. I would also like to thank Richard Stevens for reviewing the draft copy, although I accept full responsibility should any errors have crept in. Finally, and by no means least, I would particularly like to pay tribute to my wife Valerie for her support and patience while I have been engaged in producing this entire series of books.

Gordon Edgar
Ripon, North Yorkshire
January 2020

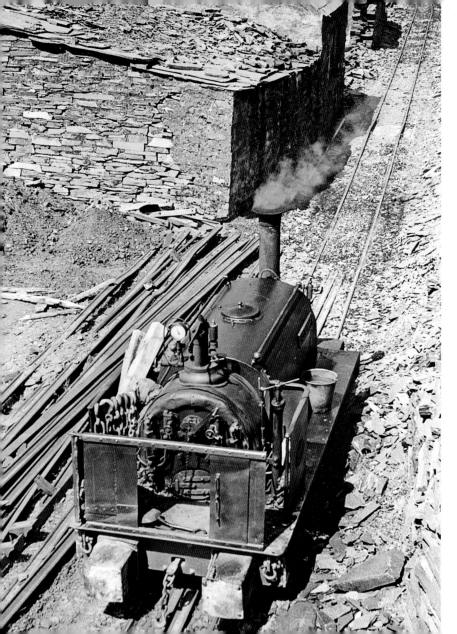

1

QUARRIES

From the early nineteenth century, the quarrying of slate and granite developed into one of the most important industries in North Wales, and arguably the most well-known were the quarries of the Dinorwic and Penrhyn slate companies, both using 1 ft 10¾ in. gauge railways. DeWinton vertical-boilered tanks, Hunslet 0-4-0 saddle tanks and Ruston & Hornsby four-wheel diesel-mechanical locos were by far the most widespread types purchased new by the quarrying companies in North Wales, but there were some quite notable exceptions, especially some of the pre-owned locos acquired from various sources during the early to mid-twentieth century. Due to the extremely restricted headroom prevalent in the tunnels at Dinorwic, enclosed cabs were unsuitable there, so the drivers had to endure the elements, but allegedly did so willingly! As the demand for slates declined, slate quarrying was gradually wound down, with the major quarry railways closing during the 1960s, although some minor narrow gauge railways continued to see use at a handful of locations elsewhere into the 1990s.

Left: Alice class Hunslet 0-4-0 saddle tank *Holy War* (W/No. 779 of 1902) between duties on the Penrhydd Bach level at Dinorwic in July 1967. Named after a racehorse, she spent most of her life on the higher levels of the quarry and was the last steam loco to work in a quarry at Dinorwic, until November 1967. Dinorwic quarry closed two years later. (Jon Marsh)

Opposite page above left: Alice class *Maid Marion* (Hunslet W/No. 822 of 1903) at Dinorwic on 20 September 1961. The identity of this and other Dinorwic locos of this class is hypothetical due to the prevalent interchange of frames and parts that took place there over many years. (John Hill – IRS collection)

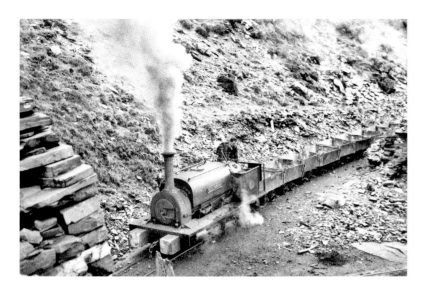

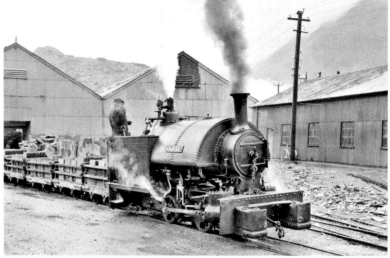

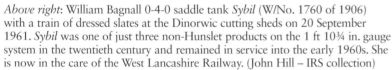

Above right: William Bagnall 0-4-0 saddle tank *Sybil* (W/No. 1760 of 1906) with a train of dressed slates at the Dinorwic cutting sheds on 20 September 1961. *Sybil* was one of just three non-Hunslet products on the 1 ft 10¾ in. gauge system in the twentieth century and remained in service into the early 1960s. She is now in the care of the West Lancashire Railway. (John Hill – IRS collection)

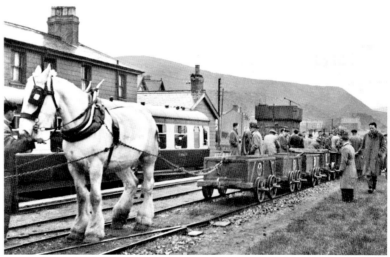

Right: The 3 ft 6 in. gauge Nantlle Railway was horse-worked throughout its life, the line serving the numerous slate quarries along the Nantlle valley and, latterly, a transhipment dock at Nantlle LNWR station from 1872. First opening for traffic in 1828, the tramway passed to the Caernarvonshire Railway Company in 1867, eventually ending up somewhat anachronistically in state ownership with BR! This situation remained until November 1963, when it is believed that the last slates were conveyed from Pen-yr-Orsedd Quarry to Nantlle, with the BR standard gauge branch closing during the December. Understandably, during its latter years it proved to be a magnet for enthusiasts' railtours, as shown here in the late 1950s, at which time the horse-drawn motive power was sub-contracted to one Mr Oswald Jones, who used his Shire horses Prince and Corwen. Noteworthy are the double-flanged wagon wheels, loose on the fixed axles, and the moveable diamonds in the trackwork. (Kevin Lane collection)

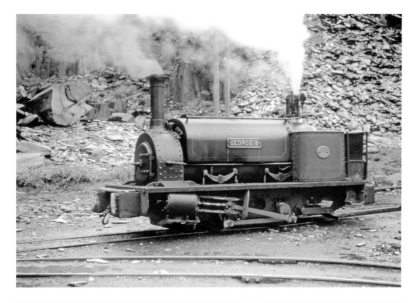

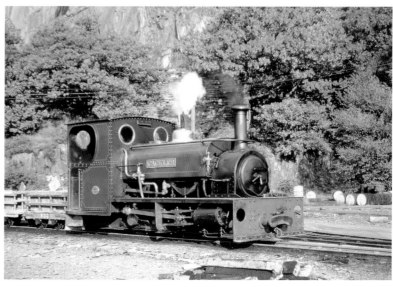

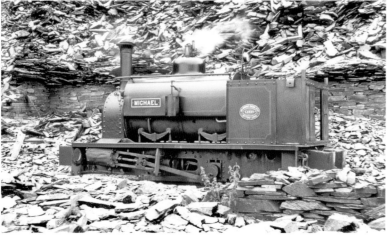

Above left: Hunslet *George B* (W/No. 680 of 1898) resting between duties at the eastern end of the Dinorwic mills at Hafod Owen on 26 June 1956. This Alice class 0-4-0 saddle tank is now on the Bala Lake Railway. (Colour-Rail)

Above right: Cab-fitted Mills class 0-4-0 saddle tank *Cackler* (Hunslet W/No. 671 of 1898) working around the Dinorwic mills at Gilfach Ddu in June 1956. (Colour-Rail)

Below left: *Michael* (Hunslet W/No. 1709 of 1932) resting between duties on the Duffryn gallery at Dinorwic on 26 June 1956. A later design of the Port class of 0-4-0 saddle tank, and the last steam loco to be built for a North Wales slate quarry, it never actually worked at Port Dinorwic, but spent its entire life in the galleries. The domed boiler, cab doors and sand pot alongside the saddle tank are noteworthy features. (Colour-Rail)

Right: Former Penrhyn Quarry Hunslet *Hugh Napier* (W/No. 855 of 1904) at Boston Lodge on 1 November 2015. After fifty years of hard quarry work, it was deemed to be worn out in 1954 and was dumped on the infamous siding at Felin Fawr awaiting its fate; however, somehow the loco escaped the cutter's torch and was donated to the Penrhyn Castle Industrial Railway Museum in 1966. In July 2011, the loco was moved to Boston Lodge Works for restoration to working order in quarry condition, including a new boiler built at Boston Lodge. It is now maintained by the Ffestiniog and Welsh Highland Railways at Boston Lodge and occasionally visits other railways. (Author)

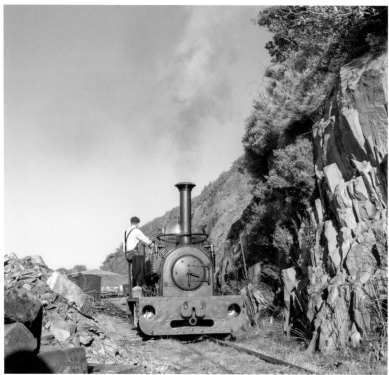

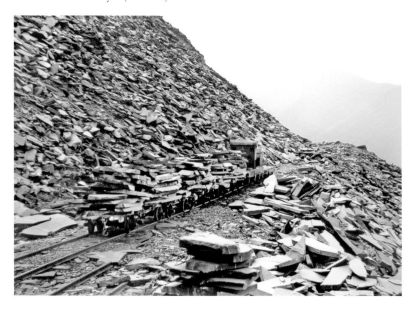

Left: On 16 May 1970, the last train of slate is seen, abandoned where it had stood following the cessation of the quarry railway operation, at the Harriet gallery of the Dinorwic Slate Quarry. The rusting and abandoned loco at the head of the train of loaded flat wagons of slate slabs, which were destined for the cutting mill but never made it, is a 1 ft 10¾ in. gauge Ruston & Hornsby 20DL class diesel-mechanical (W/No. 211620 of 1941), which was eventually cut up on site during 1977. (Author)

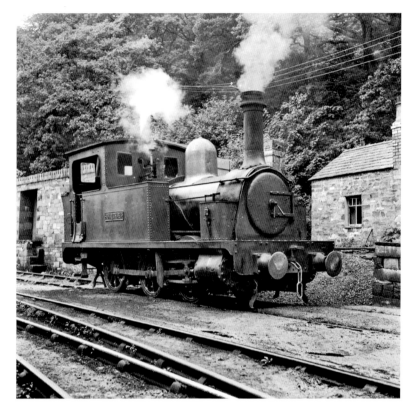

Right: An early 1950s photograph of Padarn Railway Hunslet *Velinheli* (W/No. 631 of 1895) running alongside the Afon Seiont at Pensarn with a short train of empties for Gilfach Ddu, brought from the head of the Port Dinorwic incline. The bespoke transporter wagons each accommodated four standard quarry trucks, which were run off the transporter wagons at Penscoins and taken down the incline to the port. Dismantled for repairs in November 1953, *Velinheli* was never reassembled, and her remains were scrapped, along with the two other 4 ft gauge Hunslet locos, *Dinorwic* and *Amalthea*, during 1963. (Kevin Lane collection)

Left: Finished product from the productive Dinorwic slate quarries was conveyed to Port Dinorwic, a purpose-built shipment port located on the Menai Strait and established in 1793. The original horse-worked 2 ft gauge tramroad, which connected the quarries with the port, was replaced by the 4 ft gauge Padarn Railway in 1843. There was a cable-worked incline for the final distance of 440 yards down to the port from the head at Penscoins. In 1848, the Padarn Railway purchased two new 0-4-0 tender locos, *Fire Queen* and *Jenny Lind*, built by A. Horlock of Northfleet, which were later joined by three Hunslet 0-6-0 tanks built between 1882 and 1895. Locos were maintained at Gilfach Ddu shed at Llanberis, where *Amalthea* (W/No. 410 of 1886) was photographed in the late 1950s. A switch to road transport saw the railway close in October 1961, but today some of the original Padarn Railway's route is used by the heritage 1 ft 11½ in. gauge Llanberis Lake Railway. (Author's collection)

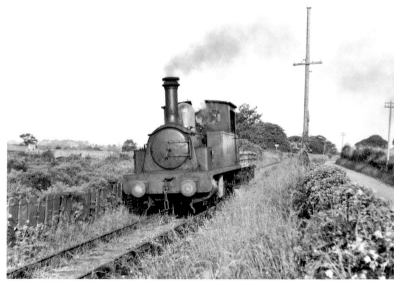

Right: One of ten 0-4-0 vertical-boilered tank locos purchased from DeWinton of Caernarfon by the Pen-yr-Orsedd Slate Quarry Ltd, 1887-built *Chaloner* is seen in steam at the quarry, located on the northern slopes of the Nantlle valley, on 26 July 1950. The vast quarry, served by the 3 ft 6 in. gauge Nantlle Tramway (see page 7), ultimately had slate mills located on three levels, served by four main pits, all with ropeways feeding wagons onto the main internal 2 ft gauge rail system connecting with the mills and tips. Loco haulage ceased during autumn 1970, with road haulage and hand-working continuing until final closure in 1979. By then it was the last commercial slate producer in the Nantlle area. (Ken Cooper – IRS collection)

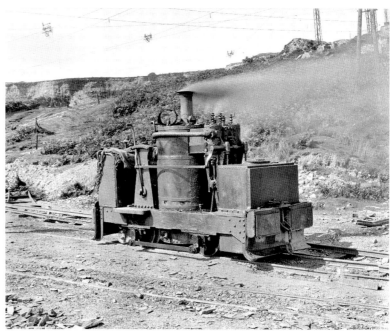

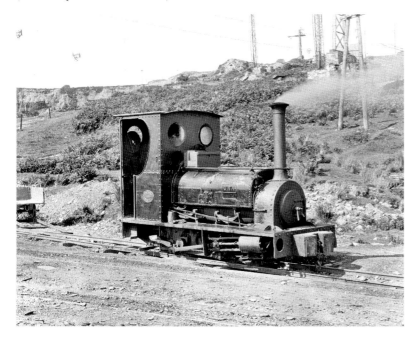

Left: Most levels within the Pen-yr-Orsedd quarry had both 2 ft gauge and 3 ft 6 in. gauge, some with mixed-gauge trackwork, facilitating direct connectivity with the Nantlle Tramway. Hunslet 0-4-0 saddle tank *Una* (W/No. 873) was the last of a trio of Hunslet locos purchased new between 1899 and 1905, augmenting the DeWinton locos, and was photographed in steam at the quarry on 26 July 1950. Four Ruston & Hornsby diesel-mechanical locos supplemented the steam fleet in the 1940s, and these 20 hp locos worked on until loco haulage finally ceased in 1970. *Una* worked at the quarry until the early 1960s, when steam traction ceased, and is now at the Welsh Slate Museum at Gilfach Ddu, Llanberis. (Ken Cooper – IRS collection)

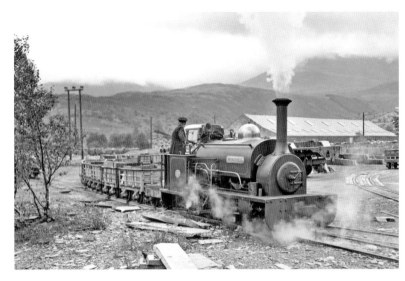

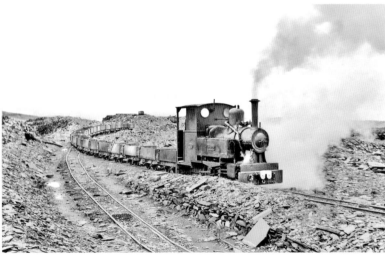

A 2 ft gauge horse-worked tramway, using double-flanged wagons and known as the Penrhyn Railroad, had first been established in 1801, running via three inclines between slate quarries near Bethesda and Port Penrhyn, just to the east of Bangor. The Penrhyn quarries first used locos in 1875, on an upgraded upper section of the line and to the gauge of 1 ft 10¾ in. By 1879, a new loco-worked line was fully operational between the quarries and the port, using almost entirely a new alignment to the original tramway and dispensing with the inclined planes, other than those in the quarries. Between 1876 and 1879, DeWinton of Caernarfon supplied Penrhyn Slate Quarries with ten four-coupled locos, seven with vertical boilers (see page 11) and three of conventional design, but these soon proved to be unsuitable to cope with the increasing traffic levels on the 'main line' and in 1882 the first of three Hunslet 10 in. x 12 in. cylinder locos were ordered. *Charles*, *Blanche* and *Linda* were to be the mainstay of the Penrhyn Railway's motive power right through to the closure of its 'main line' in June 1962, whilst the Port Penrhyn sidings and the quarries were worked by the lighter locos, as illustrated on this page. Despite a fleet of Ruston & Hornsby diesel-mechanical locos of Ministry of Supply origin, acquired in the 1940s for the port and quarry shunting, steam traction continued to be used in the quarries right up until closure in May 1965. Most of the trackwork had been lifted by the December of that year. The well-known *Blanche* and *Linda* have subsequently seen use on the heritage Ffestiniog Railway, rebuilt as 2-4-0 saddle tanks with tenders, whilst *Charles* has, since May 1963, resided in its original condition at the National Trust's Industrial Railway Museum, located within Penrhyn Castle.

Above left: Hunslet 0-4-0 saddle tank *Winifred* (W/No. 364 of 1885) positioning slate wagons at the Red Lion level, Bethesda, on 28 September 1962. The mills and workshops were established on this plateau in 1860. *Winifred* was to be the last steam loco to work here, on 18 May 1965, after which she was purchased for private preservation and shipped to the United States almost immediately, in July 1965.

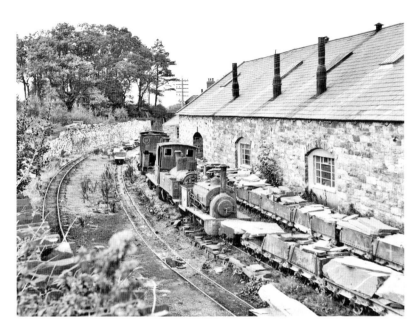

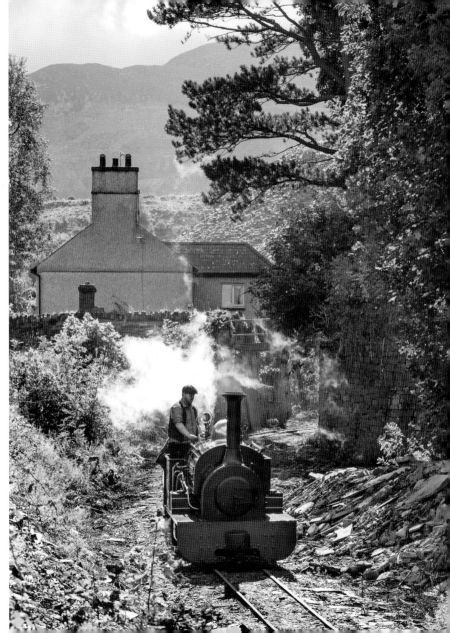

Above: The Penrhyn Slate Quarry's workshops at Coed-y-Parc on 2 October 1961, with the well-known line-up of derelict locos dumped alongside. Hunslet *Lilian* (W/No. 317 of 1883) is the nearest. (All Brian Webb – IRS collection)

Right: Quarry class Hunslet *Winifred* was repatriated by businessman Julian Birley in 2012 and in September 2016 she briefly visited the heritage Penrhyn Railway at Coed-y-Parc from her Bala Lake Railway home. Against the distinctive backdrop of the former slate quarries, she heads along a short section of the former 'main line' formation, re-laid towards Port Penrhyn. Despite the remarkable progress made by the enthusiast group based at the Felin Fawr site, some fifty years after the line's closure, the venture was sadly terminated during 2017. (Author)

Opposite page below left: During the same September 1962 visit, Avonside 0-4-0 tank *Ogwen* (W/No. 2066 of 1933) was found positioning wagons in the quarry.

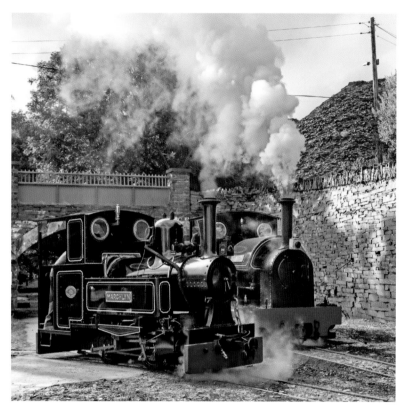

Above: A remarkable sight alongside the former Penrhyn Railway workshops on 16 September 2016 and sadly no more: 2 ft gauge Avonside 0-4-0 tank *Marchlyn* (W/No. 2067 of 1933), another repatriation from the USA, and Kerr Stuart Tattoo class 0-4-2 saddle tank *Stanhope* (W/No. 2395 of 1917), both returned to Coed-y-Parc for the Penrhyn Railway's annual gala, the last such event before its closure. (Author)

Below: A recreation in November 2015 of a typical slate quarry scene: repatriated former Penrhyn Hunslet *Winifred* with slate wagons at Dinas, Blaenau Ffestiniog, when visiting the Ffestiniog Railway (FR). The disused incline, originally serving the Oakeley Slate Quarries, is on the right, alongside the Conwy Valley line from Llandudno Junction. (Author)

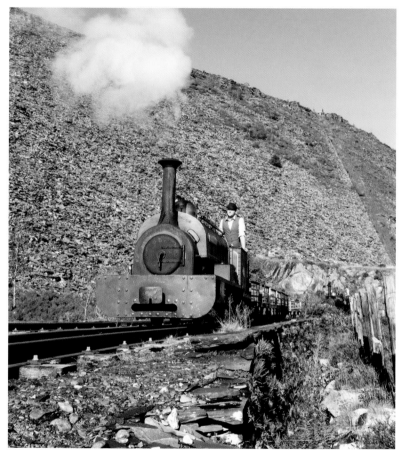

Right: A Ruston & Hornsby four-wheel diesel-mechanical 18/21 hp class (W/No. 174542 of 1935) languishing in a roofless slate-cutting shed, surrounded by abandoned machinery, at J. W. Greaves & Sons Ltd Llechwedd Slate Quarry, Blaenau Ffestiniog, on 19 August 1994. Purchased from Bergerat Dutry SA., Brussels, Belgium, for use at the adjoining Maenofferen slate mine, the 600 mm gauge loco was moved to Llechwedd in January 1978.

Below: With slate-cutting booths to the right, an unidentified 2 ft gauge Wingrove & Rogers four-wheel battery-electric stands with three loaded wagons at the Maenofferen mills of J. W. Greaves & Sons Ltd on 19 August 1994. It had been transferred from nearby Llechwedd to replace an older sister loco. The original opencast workings were developed into a deep mine when owned by the Maenofferen Slate Quarry Co. Ltd between 1861 and 1975 and it was one of many quarries to ship its slates via the FR. Taken over by road transport, the last remaining incline (No. 2) became redundant by 1977, the lower incline (No. 1) having closed by 1972. The commercial quarry operation ceased entirely in 1998, when the mill was closed. (Both author)

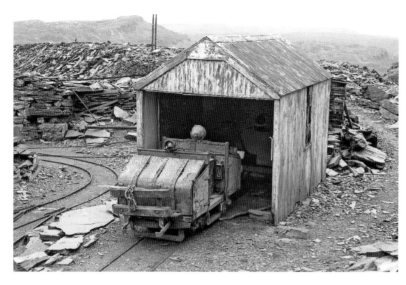

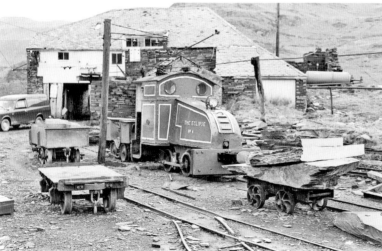

Above left: From around 1863 until 1953, the Manod Slate Quarry conveyed slate by means of the 1 ft 11½ in. gauge Rhiwbach Tramroad, also known as the Ffestiniog Extension Railway; the finished slates were taken on from Blaenau Ffestiniog to Porthmadog Harbour via the Ffestiniog Railway (FR). The tramroad climbed from the FR line at Duffws by means of three gravity-worked double-track inclines, with intermediate level sections. These were horse-worked until the 1920s, at which time a Baguley and a Muir Hill loco were purchased (see opposite page). At the top of the inclines a 'summit section' climbed on a ruling grade of 1 in 70 across moorland to the head of a single-track incline leading down to Rhiwbach Quarry, operated by a steam haulage engine. The tramway served several other quarries en route, including Maenofferen and Manod. The Manod underground caverns were occupied by the Ministry of Works during the Second World War for the secure storage of the priceless works of art from the National Gallery. These had been containerised and conveyed by the GWR during the summer of 1941, from an initial temporary secure haven in underground stone workings near Bradford-upon-Avon, and finally by mountain road to the quarry on flat-bed trucks, to be securely stored underground in purpose-built humidity-controlled brick vaults until the end of hostilities. During this time, the slate was extracted from other workings at the nearby Craig Ddu Quarry, accessed from Manod via a tunnel. The vaults were retained during much of the Cold War period, should secure storage have again been required. It was not until 1983 that the caverns were finally vacated, at that time coming under the auspices of the Department of the Environment. Mining recommenced, but slate was then extracted using road transport, the railway having been closed and the track lifted by 1956. This 2 ft gauge four-wheel battery-electric loco was around sixty years old when photographed at the Manod Slate Quarry loco shed on 13 October 1977, and was still in regular use for slate haulage on the surface. It was built by Brush of Loughborough in around 1917, allocated engine identity (not works) No. 16303. It was one of a batch of locos built for use at the Ministry of Munitions CSD 473 Store Depot at Queensferry. It is now maintained at the Amberley Museum Railway, near Arundel, in Sussex.

Below left: On 13 October 1977, this 2 ft gauge 0-4-0 overhead electric 'trolley' loco, No. 4 *The Eclipse*, was in the yard at Llechwedd Quarry. It was rebuilt there in 1927 from one of J. W. Greaves & Sons Ltd's two William Bagnall 0-4-0 saddle tanks, and is believed to use the frames from *Margaret* (W/No. 1445 of 1895). Only the principal surface lines on Floors 5 and 7 were electrified. (Both Kevin Lane)

Right: This curious 2 ft gauge 1925-built Muir Hill four-wheel petrol-mechanical tractor was found spluttering away at Blaenau Ffestiniog on 3 April 1959. It was used for moving wagons from the Maenoffern Quarry to the yards adjoining the ex-GWR and LMS yards. It had originally been purchased by the Rhiwbach Quarry for use on the summit section of the tramroad but was purchased, along with the tramroad, in 1928 by the Maenoffern Quarry. It was used until closure in 1962 on a leased section of line between Duffws and the BR exchange sidings at Blaenau Ffestiniog, and was cut up by a local scrap merchant sometime between July 1964 and July 1965. (Jim Peden – IRS collection)

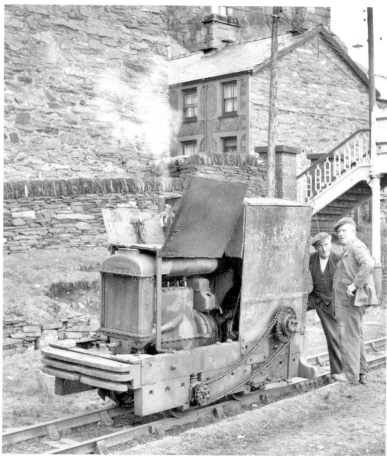

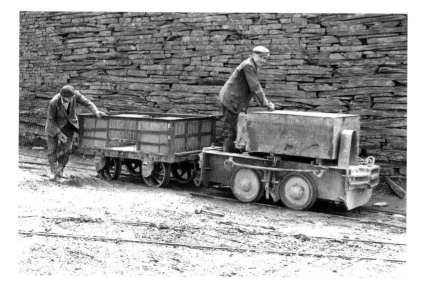

Left: An unidentified 2 ft gauge Wingrove & Rogers or Brush Electric Vehicles four-wheel battery-electric loco with a wagon of finished slate on the upper level of J. W. Greaves & Sons Ltd Llechwedd Slate Quarry, Blaenau Ffestiniog, on 22 June 1976. (Kevin Lane)

Below: Partly dismantled and long out of use Andrew Barclay 0-4-0 saddle tank *Stafford Vernon* (W/No. 1584 of 1917) at the brickworks and quarry of William Wild & Sons Ltd at Holyhead in the late-1950s. It was condemned by 1951 and scrapped during 1959 by W. J. Davies & Co. of Holyhead. The works was also known as the Holyhead Silica Works and supplied stone to the breakwater, rail-connected from the quarry. The harbour's strategic importance saw the operation come under the control of the Board of Trade/Ministry of Transport and BR supplied the railway's labour from 1976.

Opposite page: The quarry loco sheds in the late 1950s, and inside the rudimentary timber and corrugated iron buildings are (left) a Peckett 0-4-0 saddle tank (W/No. 1873 of 1934) and (right) partly dismantled and long out of use Andrew Barclay 0-4-0 saddle tank *Stafford Vernon*. The M5 class Peckett was used until March 1966, and was scrapped in August 1967. (Both author's collection)

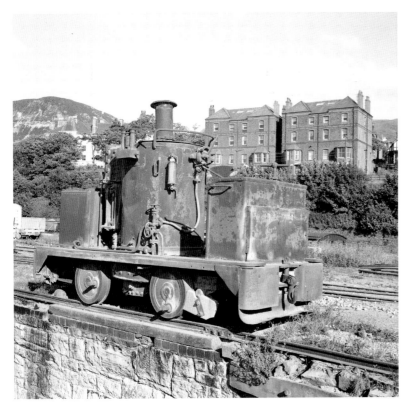

Above: 1893-built De Winton 0-4-0 vertical-boilered tank *Watkin* out of use at Penmaenmawr & Welsh Granite Quarry. It was one of eight such locos originally purchased new, later joined by five Hunslet 0-4-0 saddle tanks. The 3 ft gauge railway connected the quarries on Penmaenmawr Mountain with the pier. New Simplex diesel locos arrived from 1929 and use of steam traction ended as early as the 1940s. *Watkin* remained until 1966, eventually finding a home in the Penrhyn Castle Museum. (Kevin Lane collection)

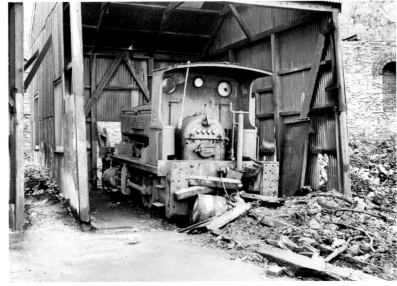

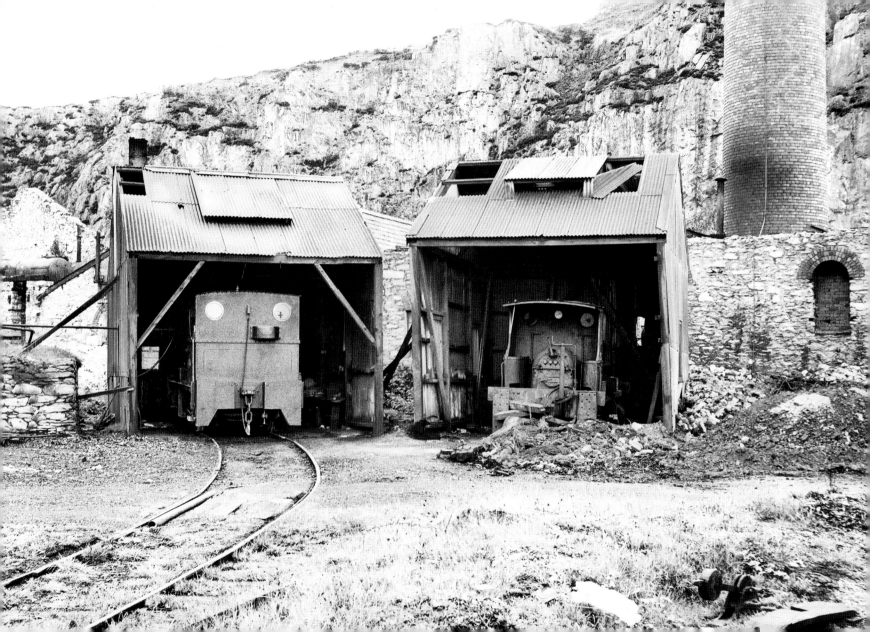

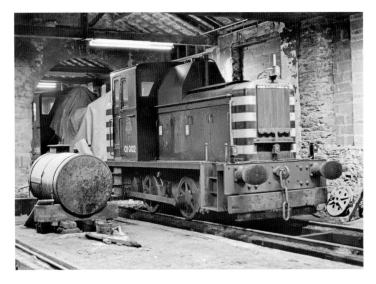

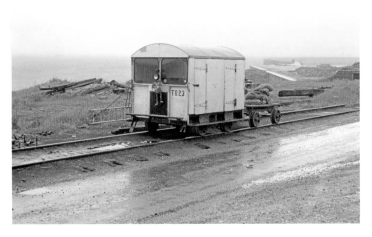

Above left: Following the withdrawal from service of William Wild's Peckett in 1966, the stone was initially conveyed between the quarry and harbour by BR departmental loco ED6, a John Fowler 150 hp 0-4-0 diesel-mechanical (W/No. 4200045 of 1949), which had been transferred from the Ditton sleeper depot near Widnes. Two 01 Class locos were drafted in to replace it during June 1967 and this was to be the staple motive power of the railway until its closure by summer 1980. On 21 June 1979, BR 01 Class Andrew Barclay 0-4-0 diesel-mechanical No. 01002 (W/No. 397 of 1956) was in the Holyhead breakwater railway's loco shed. It was originally BR No. 11505 and later renumbered No. D2955. Sheeted over behind is sister loco No. 01001 (W/No.396 of 1956). Both 153 hp Barclays were scrapped in February 1982. (John Sloane)

Below left: The two BR 01 Class locos at Holyhead received much attention from rail enthusiasts, unlike this Wickham permanent way trolley, one of two used by the BR maintenance team to travel the line. It was also used for conveying tools, a ladder, and smaller items. On 21 June 1979, TR23 (W/No. 7516 of 1956), a 10 hp Type 27A Mk III, stands on the running line complete with a Humpty Dumpty cuddly toy affixed to the front. The purpose of this isolated line, unconnected to the national railway network, was to convey stone from the William Wild & Sons Ltd quarry to the breakwater. The standard gauge railway, first installed in 1913, was disused by July 1980 and stone was subsequently moved by road vehicle whenever required. (John Sloane)

Opposite page above left: The internal standard gauge quarry railway loading point serving Aberthaw cement works on 22 August 1970, with 150 hp John Fowler 0-4-0 diesel-mechanical *Daffodil* (W/No. 4210084 of 1953). The works opened in 1912 and use of the quarry railway ceased in the mid-1980s. *Daffodil* was scrapped in 1985, followed by her two floral sisters, *Bluebell* and *Iris*, in 1989. External rail traffic to and from the works had ceased by March 1995. (Roy Burt)

Opposite page above right: A Frank Hibberd 170 hp Planet four-wheel diesel-mechanical (W/No. 3890 of 1959) at the loading point for ARC/Powell Duffryn Quarries Ltd Machen Quarry on 20 April 1990. The quarry has dispatched roadstone and railway ballast to various destinations across the South and South West for many years and is now the sole reason for the survival of the 6-mile-long freight branch from Park Junction at Newport. The loading point, now shunted by a former BR 08 Class loco, is fed from a quarry located beside the former Brecon & Merthyr Trethomas line, which also served Bedwas Navigation colliery until its closure. (Author)

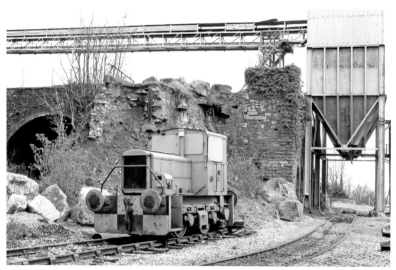

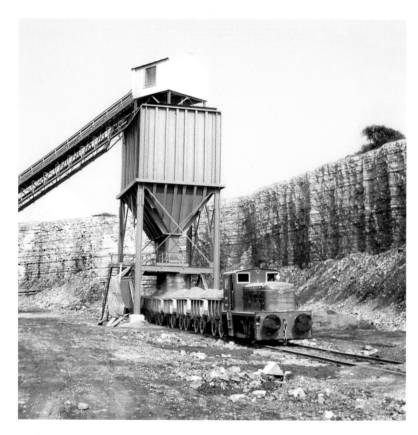

Right: This Frank Hibberd 25 hp four-wheel diesel-mechanical (W/No.1861 of 1934) is seen dumped out of use at Cily-ry-chen Limeworks, Pantyrodyn, on 27 August 1970. The 2 ft 11 in. gauge system had served the quarry faces, with the upper faces accessed by inclines. The Planet loco, possibly a reconstruction from an earlier Kent Construction-built example, worked the quarry line, along with four Ruston & Hornsby locos, but it had clearly been out of use for several years by this time. (Roy Burt)

2

SCRAP

Opposite page: A Ruston & Hornsby 192 hp 0-4-0 diesel-electric (W/No. 544998 of 1969) at the Neville's Dock works of A.M.G. Resources Ltd, Llanelli, on 21 April 1990. The works was connected to BR at Dolau Junction and recovered tin from scrap tinplate. By 1990, it was the sole user of the former Neville's Dock & Railway Co. Ltd's railway. BR disconnected the line in 1991, but the LPSE class Ruston continued to see internal use. It was the last standard gauge loco to be built by the Lincoln manufacturer, and is now preserved at the former Torrington railway station in North Devon. (Author)

Right: George Cohen Sons & Co. Ltd's scrapyard at Morriston, the site of the former Beaufort Tinplate Works, on 15 November 1982, four months before its closure. The two John Fowler 150 hp 0-4-0 diesel-mechanical locos, blue W/No. 22876 of 1939 and green W/No. 22878 of 1939, were originally with MoD Naval Mines Department at Pembroke Dock and Dept of Environment St Athan respectively. (Roy Burt)

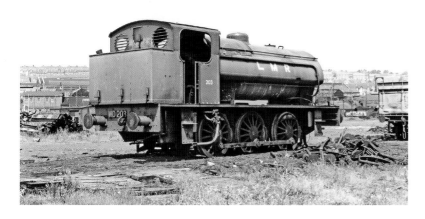

Below left: Dai Woodham's scrapyard at Barry is well known for the steam locos, over 200 in number, that were never to meet their originally intended fate when withdrawn from BR sheds and purchased as scrap metal. However, a few locos were cut up at Barry, including this Hunslet Austerity 0-6-0 saddle tank, WD203 (W/No. 3803 of 1953), seen shortly after arrival from the Longmoor Military Railway in August 1963, minus its chimney. It had only enjoyed limited service at Longmoor, following a period of storage in an MoD strategic facility, and was withdrawn as early as July 1963, immediately being despatched to the Barry scrapyard, where it was disposed of in May 1965. (Author's collection)

3

STEEL & SMELTING

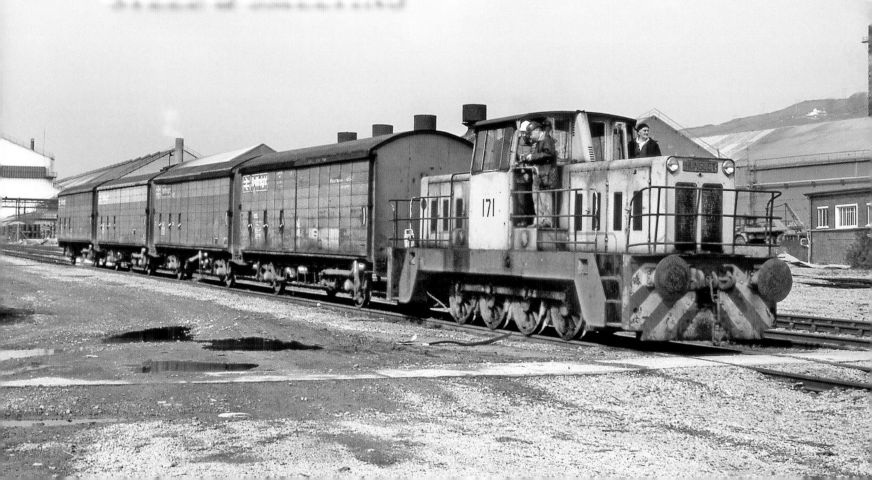

Opposite page: Eight-coupled diesel locos were a rarity in British industry, but Richard Thomas & Baldwins Ltd took delivery of a fleet of nine Rolls-Royce Sentinel class 600 hp locos in 1962 as steam traction was being phased out at Ebbw Vale steel works. A further order was placed with Hunslet in 1970 by the British Steel Corporation (BSC) for four 0-8-0 diesel-hydraulics, but rated at 776 hp. Massive Hunslet 0-8-0 diesel-hydraulic 171 (W/No. 7064 of 1971) was positioning empty Speedlink vans for loading at the Ebbw Vale Tinplate Works on 20 April 1990, shortly before a revamped internal rail system allowed direct access for main line locos. Although steel making ended in 1973, steel finishing and tinplating continued until closure in February 2001. Sister Hunslet 170 is now preserved at the nearby heritage Pontypool & Blaenavon Railway (P&BR). (Author)

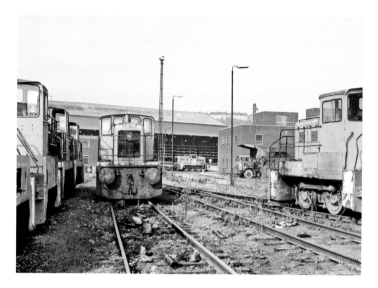

Above right: The last furnace at United Engineering Steels Ltd Brymbo Steelworks was tapped on 27 September 1990 and the final delivery was signed off in February 1991. By the time of this visit, on 13 October 1990, there was work for just one loco from a once extensive fleet of Yorkshire Engine locos, which had led a charmed existence. Framed between a line of dumped sister locos, 440 hp 0-6-0 diesel-electric *Emrys* (W/No. 2867 of 1962) trundles through the works in its eleventh hour. The Brymbo Ironworks was founded in around 1796 by John Wilkinson (1728–1808) on his Brymbo Hall estate, Denbighshire. The Brymbo Mineral & Railway Co. was formed in 1842, by Robert Roy, Henry Robertson (1816–88) and others; Robertson bought the works outright in 1872. He and managing director John Henry Darby (1858–1919) were the prime instigators of steel manufacture at the works. Brymbo Steel Co. Ltd was incorporated on 4 June 1884, and began production in January 1885. Brymbo was shut down in 1931, during the Depression, but was reopened in 1934 by the Brymbo Steel (Successors) Co. Ltd. After the Second World War the works was acquired by Guest, Keen & Nettlefolds (GKN), and re-acquired in 1955 and 1974 after periods of nationalisation, latterly from BSC (Holdings) Ltd. In 1986, the newly formed United Engineering Steels Ltd (UES) became the new owners; they oversaw the closure of Brymbo Steelworks from September 1990, sadly ending another chapter in the UK's steel making history. (Author)

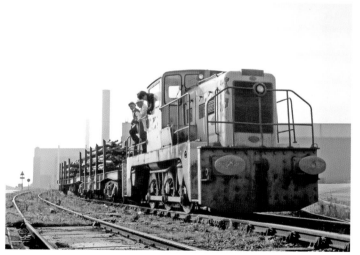

Below right: The last working loco at UES Ltd Brymbo was Janus class 440 hp Yorkshire Engine 0-6-0 diesel-electric *Emrys*, seen moving some of the last of the works' output at the weighbridge on 13 October 1990. From October 1982 the railway was used solely for moving internal traffic, but this ceased entirely in January 1991. (Author)

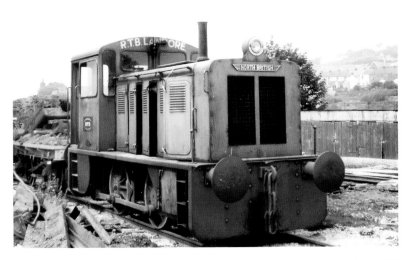

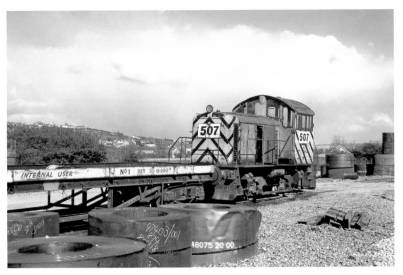

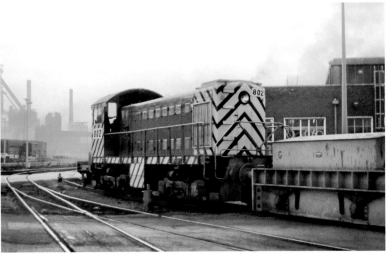

Above left: Still bearing the previous owning company's abbreviation, North British 0-4-0 diesel-hydraulic 1 (W/No. 27654 of 1956) at BSC's Landore Foundry & Engineering Works on 26 August 1970. This 225 hp loco was purchased new by Richard Thomas & Baldwin Ltd (RTB), to replace the last of the steam locos used at their Swansea works. Another two identical locos were purchased new and a further example was purchased from BR, when withdrawn from service at Eastfield depot in Glasgow (see page 124). Steel for the integrated tube works had first been produced at this site in 1867 by the Siemens Martin open hearth furnace process. Steel production ceased in 1951, but the foundry continued to operate until July 1980. This loco was initially preserved at the Swansea Industrial Museum, but was later sold for scrap. (Roy Burt)

Opposite page above right: Brush Traction/William Bagnall 335 hp 0-4-0 diesel-electric 507 (W/No. 3072 of 1954) at British Steel Plc's Trostre tinplate works at Llanelli on 18 April 1991. It had been transferred from Port Talbot to Velindre works at Swansea by August 1986, and then on to Trostre by June 1990 after production had ceased at Velindre. The Steel Company of Wales at Margam took delivery of fourteen of this class, utilising Brush equipment but built at Bagnall's Stafford works, originally with a 300 hp National engine. Nine were later converted to operate as 'master and slave' locos. Some survive today at Port Talbot, but running as single units, and some with brake tender runners converted from sister locos. (Author)

Opposite page below left: Today's Port Talbot steel works site has a long history, with copper smelting commencing at Margam as early as around 1730. The Margam Iron & Steel Works was constructed by Guest Keen Baldwins Iron & Steel Co. Ltd (GKB) on the copper works site around 1919 and this was taken over by the Steel Company of Wales Ltd in 1947, along with the Port Talbot works. With the construction of the Abbey works, the three operations were amalgamated into one massive complex. The Margam works comprised the blast furnaces and the steel melting shop, while at the new Abbey works could be found the coke ovens and rolling mills. This entire complex passed to the BSC in 1968, and today is operated by Tata Steel Strip Products UK. The Steel Company of Wales imported five Bo-Bo locos in 1950, built at the American Loco Company's works (ALCO) at Schenectady in the USA. On 24 August 1970, ALCO Bo-Bo diesel-electric 802 (W/No. 77776 of 1950) was on-shed at the BSC works. Subjected to the most arduous of duties at Port Talbot, the 660 hp Bo-Bo locos had all been taken out of service by the early 1980s, but one survives at the heritage Nene Valley Railway at Peterborough. (Roy Burt)

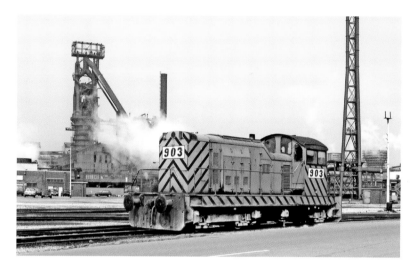

Above right: Brush-Bagnall 515 hp Bo-Bo diesel-electric 903 (W/No. 3065 of 1955) is dwarfed by one of the blast furnaces at BSC Port Talbot works on 21 April 1990. It was one of thirteen such locos built jointly by Brush Traction at Loughborough and William Bagnall at Stafford, ten rated at 515 hp built between 1955 and 1957, and three at 750 hp delivered in 1957. Improved visibility for the driver was incorporated into the original design by lowering the bonnet in front of the cab. (Author)

Below right: BSC Port Talbot on 21 April 1990, with Brush-Bagnall Bo-Bo diesel-electric 907 (W/No. 95/3140 of 1957) and two torpedo wagons. The veteran loco was rebuilt by Hunslet-Barclay at Kilmarnock in 1992 and was still in action in 2019, renumbered 07. (Author)

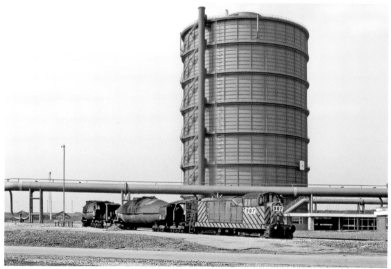

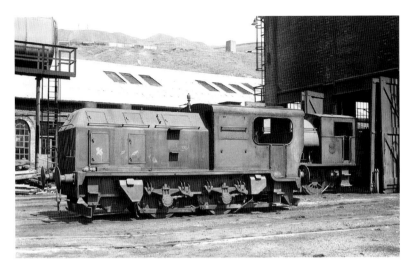

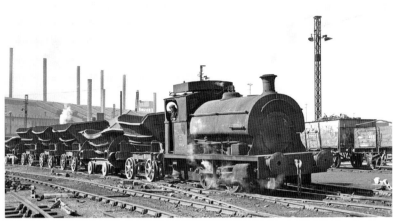

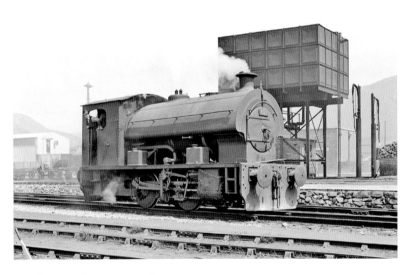

Above left: Sentinel high pressure four-wheel vertical-boilered tank RTB Ltd No. 100 (W/No. 9550 of 1952) and an unidentified Hawthorn Leslie 0-6-0 saddle tank on shed at RTB's Ebbw Vale works in the late 1950s. Diesel replaced steam traction in 1963 (see also page 25). The six-coupled Hawthorn Leslie locos worked the slag tipping traffic, the last duties entrusted to steam traction at Ebbw Vale. (Author's collection)

Left: William Bagnall 0-4-0 saddle tank 101 (W/No. 2515 of 1934) at the Steel Company of Wales's loco shed at Port Talbot, probably in the mid-1950s. With the influx of diesels from around 1950, the last steam locos were disposed of for scrap at R. S. Hayes of Bridgend by 1958. A total of twenty-five steam locos were inherited by GKB in the 1947 takeover, mainly products from Andrew Barclay, Avonside and William Bagnall (see also page 81). (Kevin Lane collection)

Opposite page above right: This Peckett W5 class 0-4-0 saddle tank (W/No. 1072 of 1907), formerly named *Joan*, but bereft of any identification, was working out her final days at the Llanelly Steel Company works in the late 1960s, at a time when the steam fleet was in the process of being eradicated and replaced by a motley collection of diesel locos, many pre-owned, some originating from BR (see also page 125). (David Moulden – Richard Stevens collection)

Right: Cut-down Andrew Barclay 0-4-0 saddle tank No. 4 *Lindsey* (W/No. 1277 of 1912) working at the melting shop of the Llanelly Steel Company works, probably in the early 1960s. Always a private concern, this Llanelli-based rolling mill for bars, billets and slabs had seen enhanced manufacturing facilities installed in 1949, and latterly in 1977 when two large electric arc furnaces replaced the nine open hearth steel melting furnaces, but sadly the owning group, Duport Ltd, collapsed during the trade recession and the works was closed in 1981. (Kevin Lane collection)

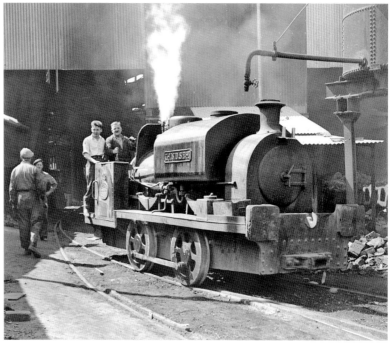

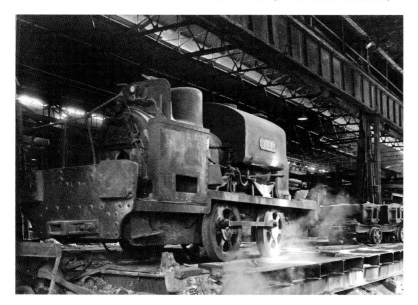

Left: Andrew Barclay 0-4-0 saddle tank No. 3 *Nora* (W/No. 1276 of 1912) out of use at the Llanelly Steel Company's works in January 1968. Supplied new to the company for these specialist duties within the restricted clearances of the melting shop, she was scrapped during the following April. (David Moulden – Richard Stevens collection)

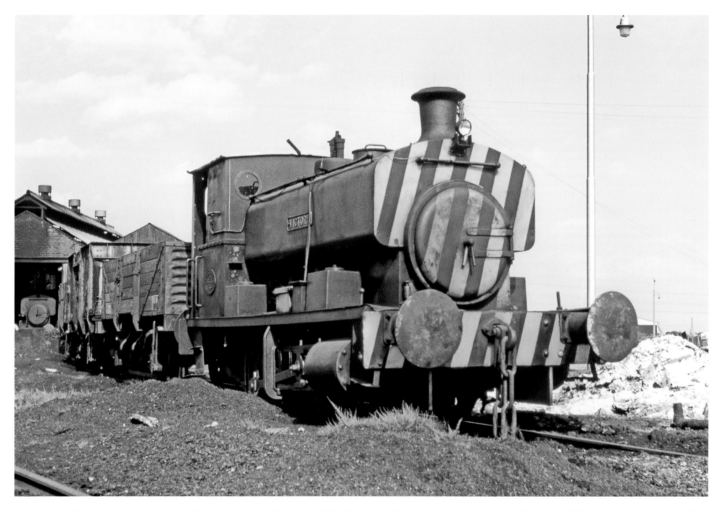

Andrew Barclay 0-4-0 saddle tank *Victory* (W/No. 2201 of 1945) at BSC (formerly Stewarts & Lloyds Ltd) Newport Tube Works in around 1969, close to the end of steam traction there. The tube works, originally opened in 1919, closed during July 1973. (Author's collection)

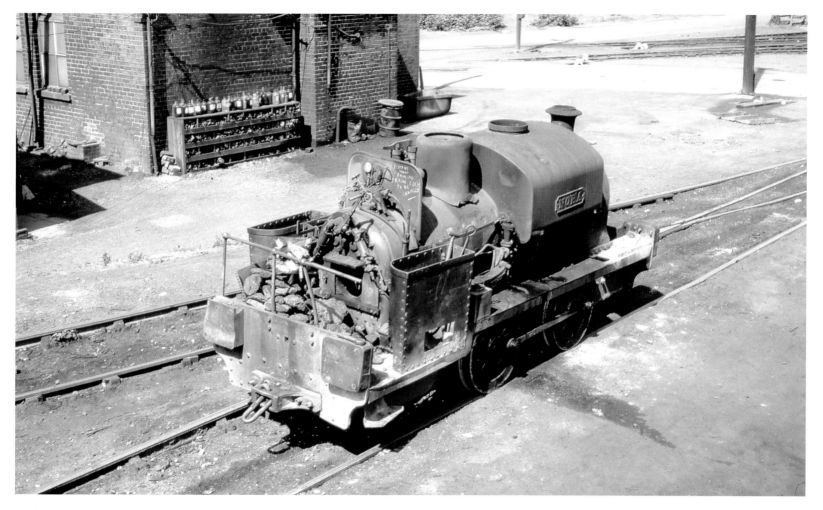

Andrew Barclay 0-4-0 saddle tank No. 3 *Nora* outside the running shed at the Llanelly Steel Company Ltd's works on 7 July 1967. She was the last of the fleet of four 'cut-down' inside-cylinder Barclays employed on the melting shop duties. (Colour Rail)

Right: From humble beginnings in 1760, the Dowlais Ironworks at Merthyr Tydfil grew into a highly profitable iron and steel producer by the first quarter of the twentieth century. However, the Great Depression sealed its fate in the shrinking market. Its inland location and the dominance of the more modern works at Cardiff and Port Talbot saw its furnaces blown out as early as October 1930. Although steel making had ceased, the foundries and engineering shops survived, and these were taken over by BSC in 1974, but closure finally came in 1987, after which the site was cleared. In December 1947, Kitson 0-6-0 tank 15 (W/No. 3872 of 1899) is seen with a train on the internal railway of the by then GKB-owned Dowlais works. Formerly GWR No. 688, and prior to that Cardiff Railway No. 8, it was purchased with five other surplus GWR tank locos in May 1927, but all were scrapped by 1950. (Harry Townley – IRS collection)

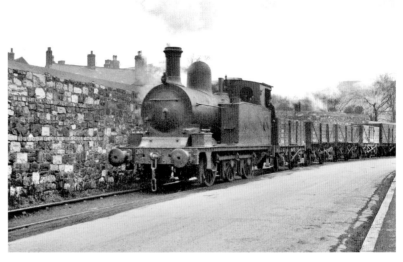

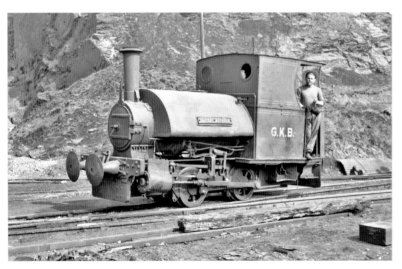

Left: William Bagnall 2 ft 4½ in. gauge 0-4-0 saddle tank *The Doll* (W/No. 1787 of 1905) at GKB Briton Ferry Ironworks sometime in the 1950s. Originally opened in 1847, the narrow gauge tramway serving the works had been converted to loco operation in 1882. The Briton Ferry works was closed in January 1959 and the track was immediately lifted. The two surviving Bagnall locos, both originally purchased new by the Briton Ferry Works Ltd, were scrapped in the September of that year. (Kevin Lane collection)

Opposite page: The other William Bagnall 0-4-0 saddle tank to be found working at GKB Briton Ferry during the 1950s was *BFW No. 5* (W/No. 2062 of 1917), which is seen busy moving laden slag ladles away from an active blast furnace at the works in April 1956. (Harry Townley – IRS collection)

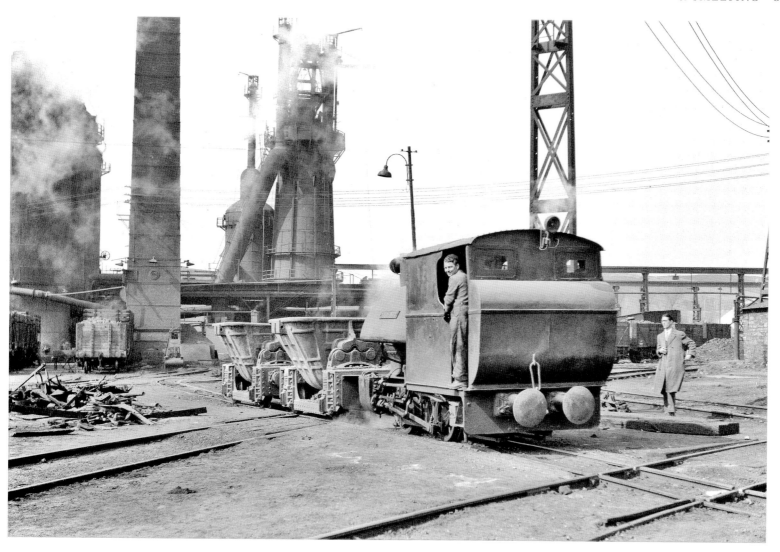

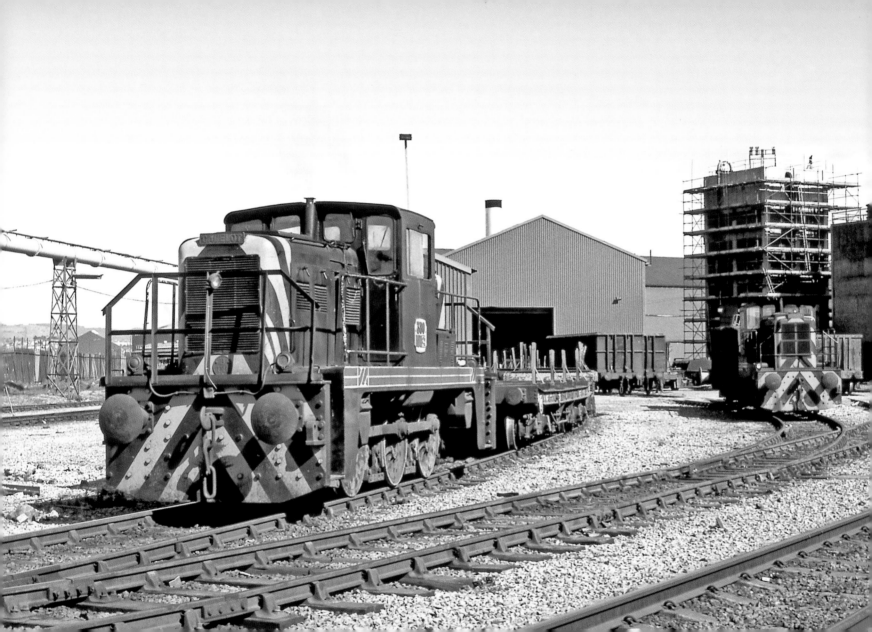

Opposite page: Yorkshire Engine Company 400 hp 0-6-0 diesel-electric Janus class *Camelot* (W/No. 2640 of 1957) and 300 hp *Calleva* (W/No. 2769 built in 1959) at Allied Steel & Wire Ltd's Tremorfa Works, Cardiff, on 20 April 1991. Both locos were originally dock shunters with the Port of London Authority at Custom House. The works today is owned by Celsa Manufacturing (UK) Ltd, and shunted by third-party former BR 08 Class locos under contract. (Author)

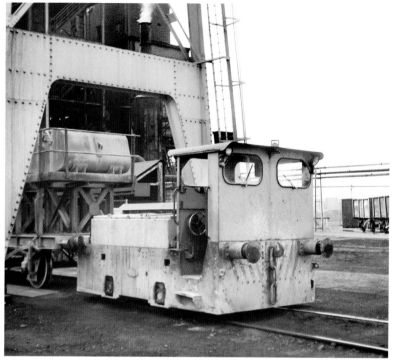

Above: Greenwood & Batley 50 hp four-wheel battery-electric *Swansea Vale No. 3* (W/No. 2942 of 1959) positioning wagons at ISC Chemicals Co. Ltd Llansamlet smelter on 27 August 1970. Its duties were soon to become redundant, and it was scrapped during 1972.

Left: During the First World War, this Swansea Vale works was a controlled establishment under the Munitions of War Act 1915. In addition to the standard gauge, it used a fleet of six 1 ft 8 in. gauge Lister Railtrucks, plus two 2 ft gauge locos constructed 'in-house' from Lister parts by the National Smelting Co. Ltd. These worked the slag point, and on 27 August 1970, 1961-built four-wheel diesel-mechanical 9 was at work. It was scrapped during the following year and the works was closed in 1974. (Both Roy Burt)

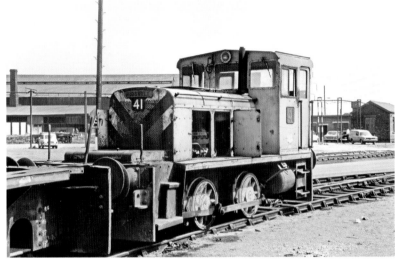

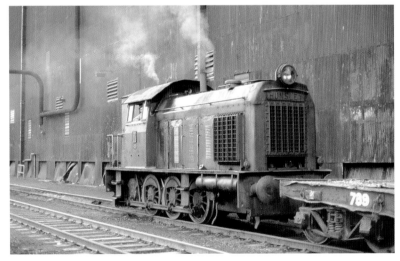

Above left: Production commenced at the John Summers & Sons Shotton works in 1896, built on land reclaimed from the River Dee estuary. The extensive works contracted in size when steel making ceased in 1980 under the ownership of British Steel. Production thereafter was concentrated on the treatment of steel strip manufactured elsewhere. The works embraced diesel traction early, dispensing with its fleet of Hudswell Clarke steam locos, largely by the early 1960s. Early arrivals, North British 0-6-0 diesel-hydraulic No. 3 (W/No. 27412 of 1954) and No. 1 (W/No. 27649 of 1956) are seen at Shotton on 26 May 1978, but both were scrapped during the following year. (John Sloane)

Above right: Hudswell Clarke 107 hp 0-4-0 diesel-mechanical No. 41 (W/No. D1020 of 1956) at Shotton on 26 May 1978. (John Sloane)

Left: Hard at work at BSC Shotton in the early 1970s was Hunslet's former demonstrator loco, 500 hp 0-6-0 diesel-mechanical No. 7 (W/No. 4003 of 1954), of a type built for the Central Railway in Peru. It was scrapped in 1976. (Colour-Rail)

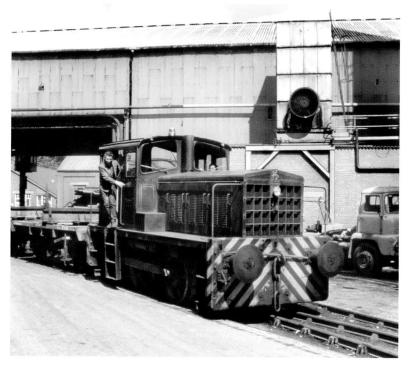

Right: From around 1949, Shotton Steelworks used a 2 ft 6 in gauge system at both the hot and cold strip mills at its Hawarden Bridge works, initially using battery-electric locos supplied by Greenwood & Batley, and later by Wingrove & Rogers. From 1971, 120 hp diesel locos were procured, and these were allocated to the stockyard and the hot and cold strip mill transfer duties. On 15 April 1993, this Hudswell Badger 0-6-0 diesel-mechanical (Hudswell Clarke W/No. DM1447 – Hunslet W/No. 8847 of 1981) was working the stockyard, the works by then under the ownership of British Steel Plc. The narrow gauge system was dispensed with in 2001. Now owned by TATA Steel Europe, only the standard gauge duties between the works and the exchange yard remain, in the hands of three contract-hire locos, a Sentinel class four-wheel diesel-hydraulic and two former BR 08 Class locos. (Author)

Left: BSC Whiteheads Works (formerly Courtybella Works) at Newport had continuous hoop and strip mills when opened in 1921 by the Whitehead Iron & Steel Co. Ltd. Bar mills, cold rolling strip mills and an electrolytic plant were added later, but it was an early casualty, closing during 1981, leading the way for so many other steel plants to follow over the ensuing years. On this 17 August 1970 visit, this Thomas Hill 178 hp 0-4-0 diesel-hydraulic (W/No. 139C of 1964 – a rebuild from John Fowler W/No. 4210014 of 1950) was busy within the works. Between 1923 and 1950, an unusual Baldwin 0-6-0 pannier tank, *Courtybella* (see page 83), worked for Whitehead, a company which courted diesel traction early, its first new John Fowler arriving in 1940, followed by another in 1945, and two more in 1950, including this example. This Thomas Hill rebuild was scrapped during 1977. (Roy Burt)

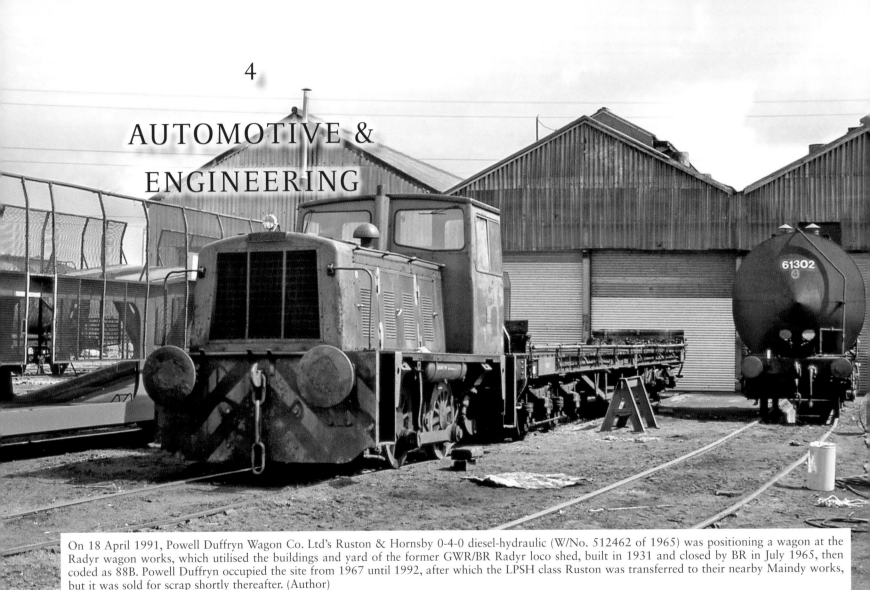

AUTOMOTIVE & ENGINEERING

On 18 April 1991, Powell Duffryn Wagon Co. Ltd's Ruston & Hornsby 0-4-0 diesel-hydraulic (W/No. 512462 of 1965) was positioning a wagon at the Radyr wagon works, which utilised the buildings and yard of the former GWR/BR Radyr loco shed, built in 1931 and closed by BR in July 1965, then coded as 88B. Powell Duffryn occupied the site from 1967 until 1992, after which the LPSH class Ruston was transferred to their nearby Maindy works, but it was sold for scrap shortly thereafter. (Author)

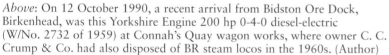

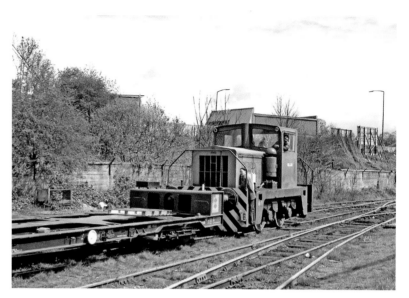

Above: On 12 October 1990, a recent arrival from Bidston Ore Dock, Birkenhead, was this Yorkshire Engine 200 hp 0-4-0 diesel-electric (W/No. 2732 of 1959) at Connah's Quay wagon works, where owner C. C. Crump & Co. had also disposed of BR steam locos in the 1960s. (Author)

Above right: A Thomas Hill Vanguard four-wheel 256 hp diesel-hydraulic (W/No. 182V of 1967) at Powell Duffryn's Maindy wagon works on 18 April 1991. An arrival from Booth's scrapyard at Rotherham in around 1989, it was transferred to the Port Tennant works in June 1993. (Author)

Right: A Hudswell Clark 307 hp 0-6-0 diesel-hydraulic (W/No. D1377 of 1966 – rebuilt Hunslet 9039 of 1979) at Ford Motor Co. Ltd's Bridgend factory on 19 April 1991. The car engine plant was opened in 1980, with rail services to and from Dagenham and Halewood. This Hunslet rebuild had been replaced by a sequence of hire locos since 2000. Sadly, closure of the factory, manufacturing high-efficiency petrol engines for Ford and Jaguar Land Rover, was announced in 2019. (Author)

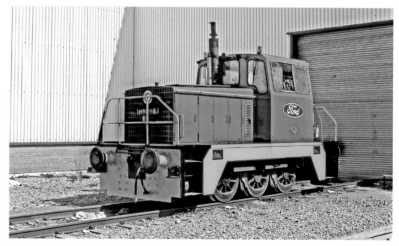

5

ELECTRICITY

Right: Peckett R4 class 0-4-0 saddle tank *Uskmouth 2* (W/No. 2148 of 1952), one of an identical pair, out of use at CEGB Uskmouth power station on 17 August 1970, just a few weeks before being cut up on site. (Roy Burt)

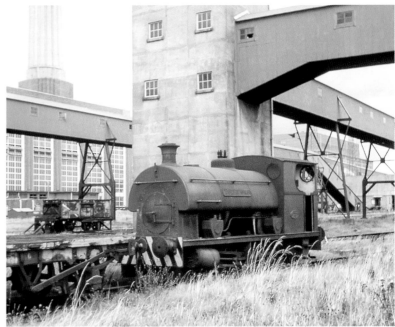

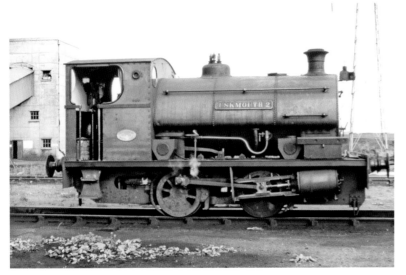

Left: During happier times, *Uskmouth 2* was active in June 1967 at Uskmouth, also known as Fifoots power station. The coal burning station 'A' began generating in December 1952, and 'B' station during 1961. Both were served by sidings at the end of the East Usk branch. 'A' station was demolished in 2002, but 'B' station has been refurbished to burn biomass and waste plastic from 2020. (Author's collection)

Opposite page above left: A Peckett 200 hp 0-6-0 diesel-mechanical (W/No. 5014 of 1959) at CEGB Aberthaw power station on 22 August 1970. During 2019 it was announced that the power station would close in March 2020. (Roy Burt)

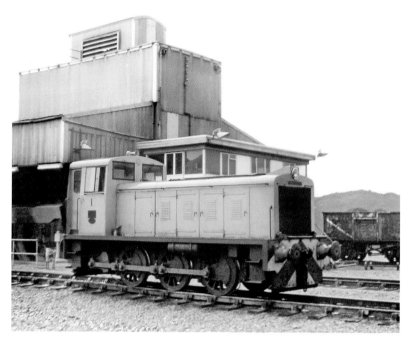

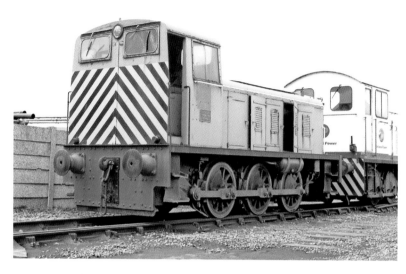

Above right: The Peckett diesel, in the company of a Darlington-built English Electric 195 hp 0-6-0 diesel-mechanical (W/No. 8199 of 1963), a BR 04 Class lookalike, at the by then National Power administered power station, on 18 April 1991. Only five Peckett diesel locos were built, between 1955 and 1959. Supplied new to the CEGB, it remained out of use at Aberthaw for many years, but was moved to the East Somerset Railway at Cranmore in 2006 for cosmetic attention before being 'plinthed' on site. (Author)

Right: Andrew Barclay 204 hp 0-4-0 diesel-mechanical *Carmarthen Bay No. 2* (W/No. 393 of 1954) at CEGB Carmarthen Bay power station, Burry Port, on 25 August 1970. This and a sister loco were supplied new to the British Electric Authority generating station, to the east of Burry Port Harbour. (Roy Burt)

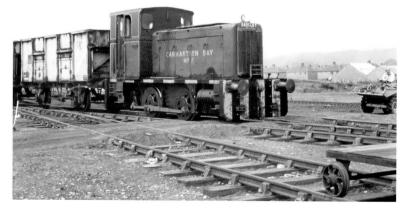

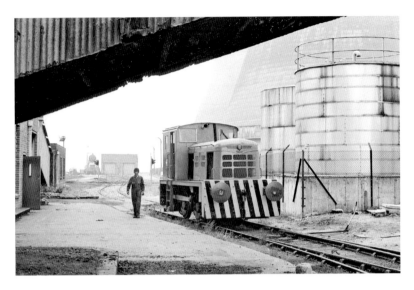

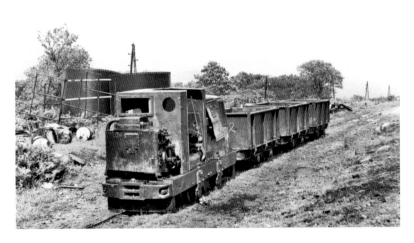

Above left: John Fowler 0-4-0 diesel-mechanical No. 1 (W/No. 421077 of 1952) at CEGB Connah's Quay power station on 9 June 1979, one of three identical 150 hp locos there. Coal was supplied from nearby Point of Ayr colliery, but rail traffic ceased in 1982. Opened in 1954, final closure of the power station took place in 1984. (Kevin Lane)

Above: Andrew Barclay 0-4-0 diesel-mechanical No. 1 (W/No. 392 of 1954) in the BR exchange sidings at CEGB Carmarthen Bay power station on 3 September 1982, two years before its closure. (Jim Peden – IRS collection)

Left: Contractor WM Latimer & Co. Ltd's 20DL class Ruston & Hornsby four-wheel diesel-mechanical (W/No. 226292 of 1944) working a pipeline maintenance train on the 2 ft gauge Cowlyd Tramway in June 1965, when it was maintained on behalf of the CEGB and British Aluminium Company at Dolgarrog. The tramway was opened in 1916 to convey men and materials to the Llyn Cowlyd reservoir, but was disused by 1968. (Harry Townley – IRS collection)

6

COAL

Arguably the most visited region of Britain by industrial steam enthusiasts was South Wales, certainly during the 1970s, when a remarkable variety of locomotive types, including a handful of pannier tanks sold out of main line service, could be found in daily use. Maesteg, Maerdy, Mountain Ash, Merthyr Vale, Brynlliw, Blaenavon, Nantgarw, Pontardulais, Talywain and other places became a focus of attention and well-known centres of pilgrimage by many photographers starved of steam activity following the demise of main line steam traction on British Railways in August 1968. As will be discovered within this chapter, there were many other small pockets of regular steam activity to be sought out in Wales. For example, Bersham and Gresford collieries, near Wrexham, could be relied upon for providing the sight of regular steam action in an area otherwise totally devoid of such a spectacle since around 1967. There were also some fascinating non-steam traction 'discoveries' for those with a broader interest in industrial railways and the lesser gauges, including some privately owned mines employing pit ponies. Sadly, all of this is now but a memory. The last deep mine in Wales was to be Tower colliery at Hirwaun in the Cynon Valley, which ceased winding on 25 January 2008. It has a claim in history as the oldest continuously worked deep coal mine in the United Kingdom, if not the world. The Big Pit mining museum at Blaenavon, and the co-located heritage Pontypool & Blaenavon Railway, with its fleet of locos of an industrial pedigree, help to keep alive memories of an era far removed from today, and are both well worth visiting. The choice of image for the front cover for this book, although contemporary in

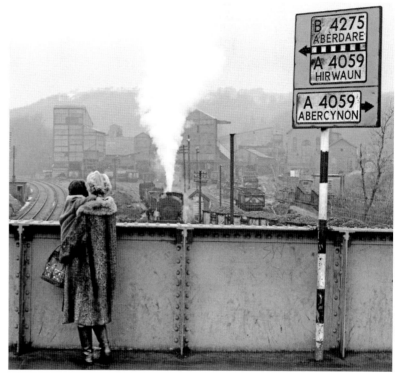

In what was an everyday scene in the Cynon Valley back in the early 1970s, a young child is given a helping hand to see over the bridge parapet at Mountain Ash, as Avonside 0-6-0 saddle tank *Lord Camrose* (W/No. 2008 of 1930) goes about its duties at Deep Duffryn colliery and washery. (Tony Brown)

nature, recognises Blaenavon's significant contribution to the Industrial Revolution in Wales. The sight and sound of a hard-working four or six-coupled saddle tank hauling a rake of mineral wagons, once an everyday occurrence in the twentieth century in South Wales, can happily occasionally still be experienced there to this day.

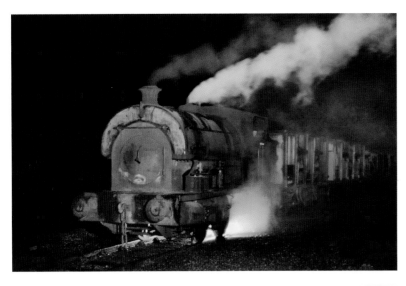

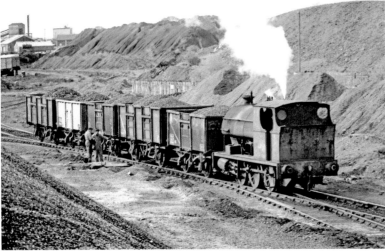

Above left: In the 1970s, Brynlliw colliery at Grovesend, just east of Llanelli, had a trio of six-coupled Peckett saddle tanks at its disposal, one B2 and two of the B3 class, for working the landsale yard and for undertaking the trip workings between the colliery and the BR exchange sidings, which were located 2 miles south-east of Pontardulais station. The former LNWR Pontardulais to Swansea Victoria line was used until its closure by BR in 1974, after which a remaining stub adjoining the former GWR Swansea District line became the sole connection with the BR main line. Most movements could be viewed from a strategically placed minor road bridge, located approximately mid-way between the colliery and the exchange sidings and from which the photo on the opposite page was taken. The colliery's proximity to the Pontardulais-Graig Merthyr NCB system made it a popular venue for photographers, that was until September 1981 when a six-coupled English Electric diesel was transferred from Mountain Ash shed, bringing an end to the previously much sought after regular steam activities there. However, the diesel's reign proved to be short-lived, for the colliery closed in September 1983. The favoured loco in later years was the younger of the brace of 14 in. × 22 in. cylinder B3 class Peckett 0-6-0 tanks, the anonymous W/No. 2114 of 1951. This loco found temporary fame by featuring in the 1972 film *Young Winston*, directed by Richard Attenborough. The railway sequences were filmed on the adjacent BR line. Latterly, the Peckett was referred to as 'Winston's Chariot', but this temporary fame apparently had no bearing on its external presentation at Brynlliw. In atrocious external condition, it is seen slipping violently as it attempts to get some loaded coal wagons on the move in the landsale yard during an evening shunting session, believed to have been in the late 1970s. (Author's collection)

Below left: On 5 May 1975, the driver of Peckett 2114 converses with the shunter in between wagon positioning movements between Brynlliw colliery, seen top left, and the landsale yard, located behind the photographer. (Author)

Opposite page: On the clear and frosty morning of 18 November 1977, the favoured B3 class Peckett was this time putting on an impressive show moving loaded wagons from the BR exchange sidings, passing the landsale yard, and heading on towards the colliery. In addition to coal wound there, Brynlliw also provided washing facilities for coal from other pits, including Graig Merthyr. The coal was tripped by BR over the short distance from Pontardulais until Graig Merthyr's closure in June 1978. The Pontardulais exchange sidings were located just beyond the then lightly trafficked M4 motorway, visible in the background. (John Brooks)

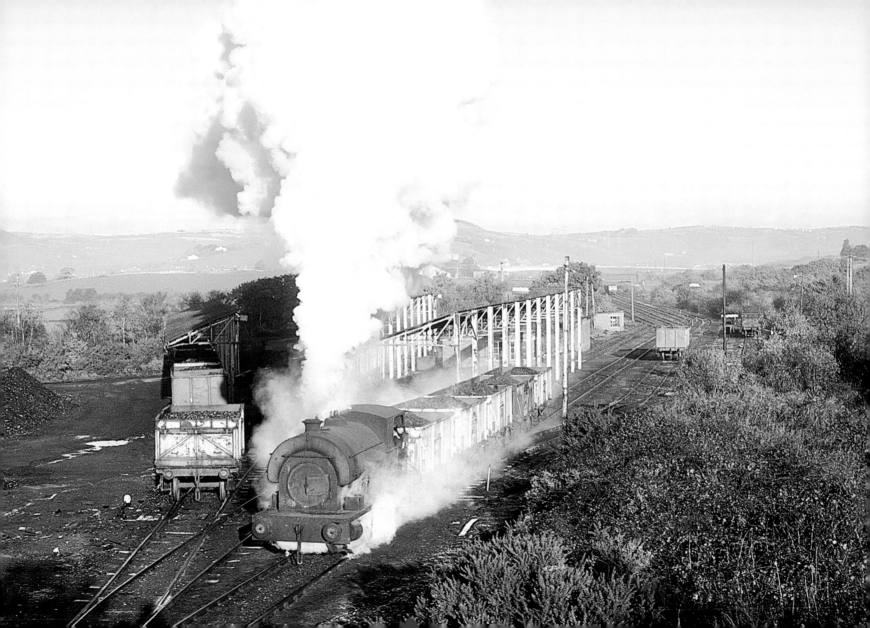

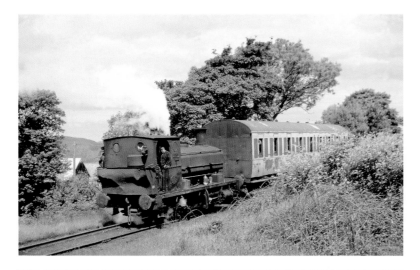

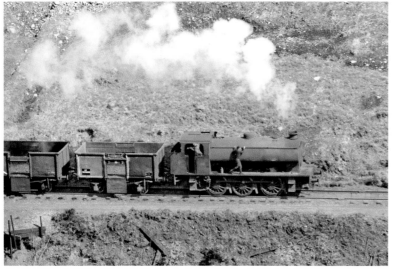

The secluded Graig Merthyr colliery was situated high in Cwm Dulais, approximately 7 miles north-west of Swansea, and it wound its first coal in 1872. It was served by a branch line of just over 3 miles in length, originally enjoying a connection at Pontardulais with the former LNWR Central Wales Line and, latterly, the GWR's Swansea Avoiding Line. The GWR connection was exclusively used by the NCB. The average load of around ten wagons from the colliery necessitated seven or eight trips per day over the branch line, plus incoming stores and supplies. The miners' train duties would be shared by either one of the veteran Andrew Barclay 0-4-0 saddle tanks, or an Austerity saddle tank, but this service ceased to operate from 1970. Miners' accommodation was provided in one of two tatty former GWR bogie compartment coaches. Some four-wheel vans with seating installed within were also used, and this was the only form of accommodation before the coaches were acquired in the mid-1950s. The locos worked bunker-first on the steep downhill gradient. Graig Merthyr colliery did not possess a washery and its output was moved by BR to Brynlliw for treatment. Over three-quarters of Graig Merthyr's coal, in later years around 3,000 tons per week, was consumed by Carmarthen Bay power station (see pages 41 and 42). Graig Merthyr became worked out and closed in June 1978, but steam continued in use until the summer of 1980, when the stockpiles became exhausted.

Above left: Andrew Barclay 0-4-0 saddle tank *Glan Dulais* (W/No. 1119 of 1907) in charge of the worker's 'Paddy train' at Banc-y-Bo, below Goppa Hill, just before the level crossing at Pontardulais, on 10 June 1967. (Colour-Rail)

Below left: On 5 May 1975, Hunslet Austerity 0-6-0 saddle tank *Norma* (W/No. 3770 of 1952) climbs up the Dulais valley towards Graig Merthyr colliery with a rake of ten empties, the fireman confidently wandering along the loco's running plate. There had been a loco availability crisis from 1971, when the Barclays became unserviceable and the Austerities required essential maintenance. For the short-term 08 Class locos were hired-in from BR, augmented by a Drewry 0-6-0 diesel-mechanical from dealer A. R. Adams for shunting at Pontardulais. The 08 Class were not popular with the crews, so in February 1973 *Norma* was transferred from Maesteg, thereafter becoming a regular performer at Pontardulais. (Author)

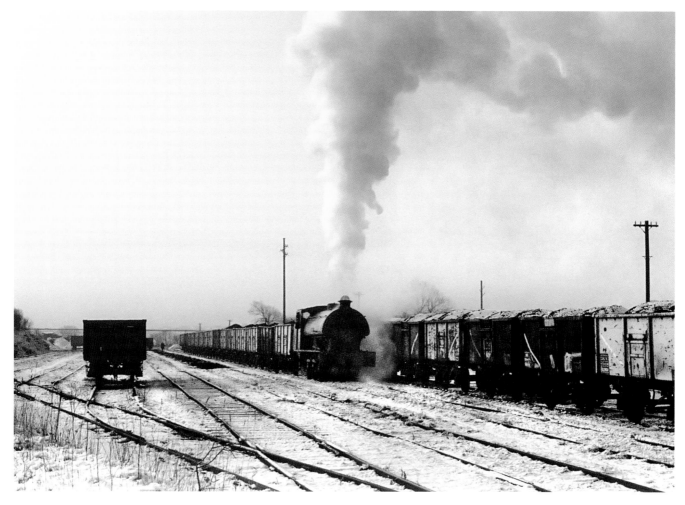

On 17 February 1978, *Norma* was shunting newly arrived wagons in the yard at Pontardulais. At this time just two Austerities were required, one for this yard duty and the other for working to and from Graig Merthyr colliery. (John Brooks)

Right: One of two Andrew Barclay four-coupled sexagenarians in the fleet at Pontardulais in the late 1960s is being prepared on the Town Shed, ready for its day's shunting work in the BR exchange and landsale sidings. (Tony Brown)

Below: In January 1968, an unidentified Austerity 0-6-0 saddle tank (probably William Bagnall 2758 of 1944) is coming to a halt at the modest town platform, just before the A48 level crossing at Pontardulais. The guard is preparing to dismount from the former GWR nine-compartment third coach. The two vans at the rear were also used as additional passenger accommodation. (David Moulden – Richard Stevens collection)

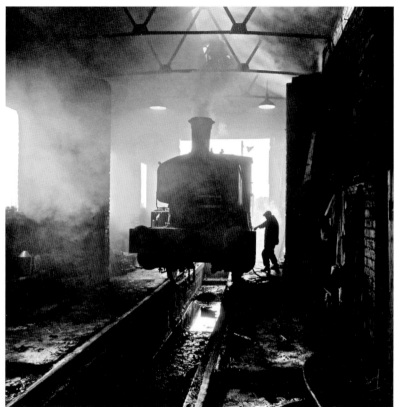

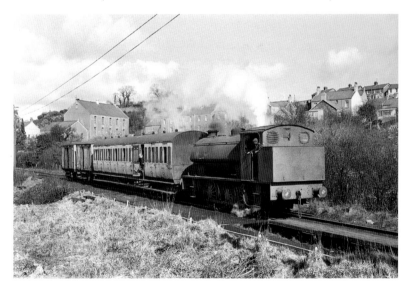

Opposite page: In the late 1960s, a William Bagnall Austerity (W/No. 2758 of 1944) crosses the main A48 Swansea–Carmarthen trunk road at Pontardulais and commences the assault of the severe climb up past Goppa with empties for Graig Merthyr colliery (Tony Brown)

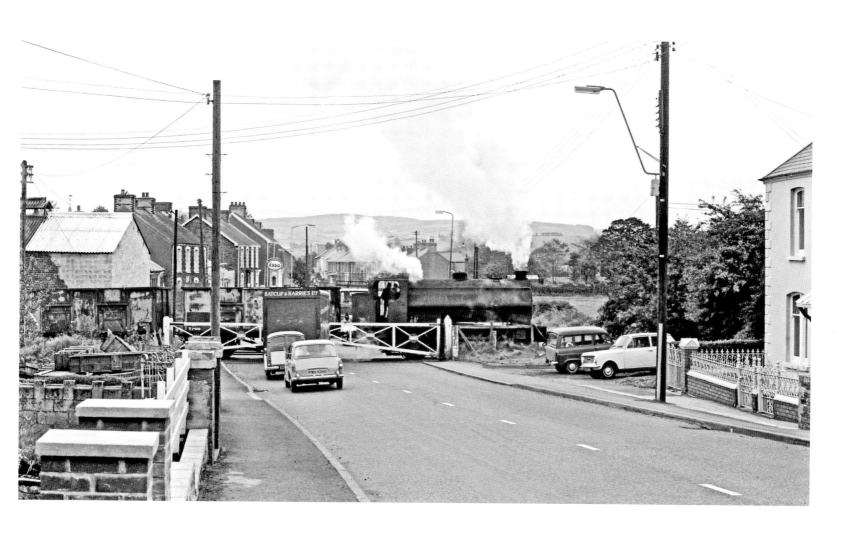

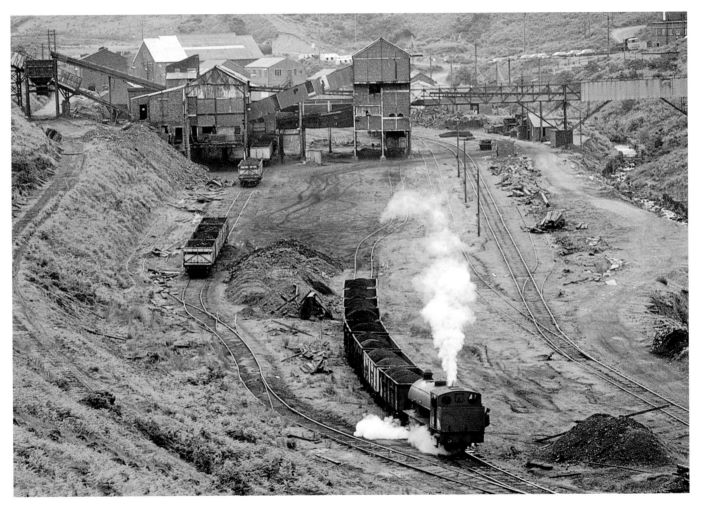

On 20 June 1978, during the last full week of operation at Graig Merthyr colliery, *Norma* assembles a train of loaded wagons, ready for one of her last journeys down the valley to Pontardulais. (John Brooks)

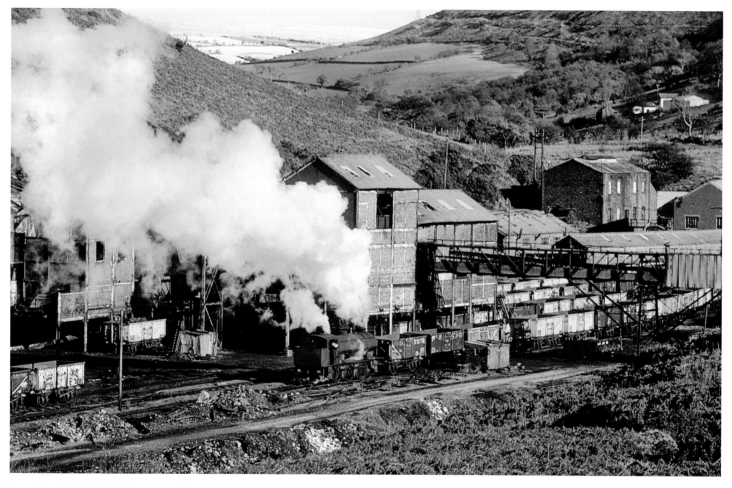

On 18 November 1977, the William Bagnall Austerity (W/No. 2758 of 1944) had brought the second train of empties that day from Pontardulais up to Graig Merthyr colliery around mid-morning and, having just run around the wagons, was propelling the rake to the sidings above the screens. They would then run by gravity through the loading screens, an operation that would make any Health & Safety Executive officer's eyes water today! (John Brooks)

Right: Ruston & Hornsby 2 ft gauge 31 hp LBU class four-wheel diesel-mechanical *Janet* (W/No. 504546 of 1963) emerges from the Pen Rhiwfawr adit with a well-loaded train at Llewellyn & Wilkins Ltd Parc Level colliery on 27 August 1970. This private mine closed in 1993. (Roy Burt)

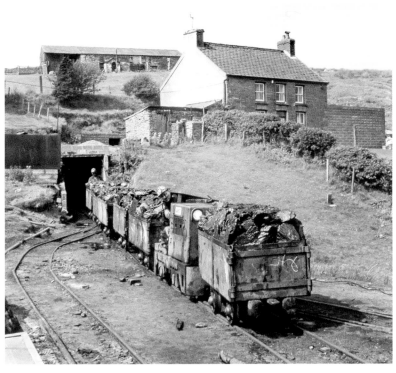

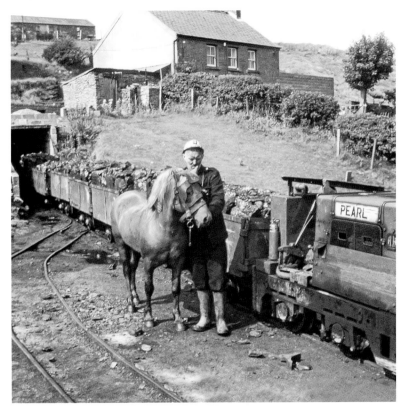

Left: Pit pony Tinkerbell at Parc Level colliery on 27 August 1970, with 2 ft gauge Ruston & Hornsby LBT class *Pearl* (W/No. 432648 of 1959) on the right. (Roy Burt)

Opposite page: A pit pony conveys pit props and miners in drams to the pit at Blaenserchan colliery, Pontypool, in spring 1969. This NCB colliery ceased winding later that year. In the background can be seen the site of the former Llanerch colliery. (Author's collection)

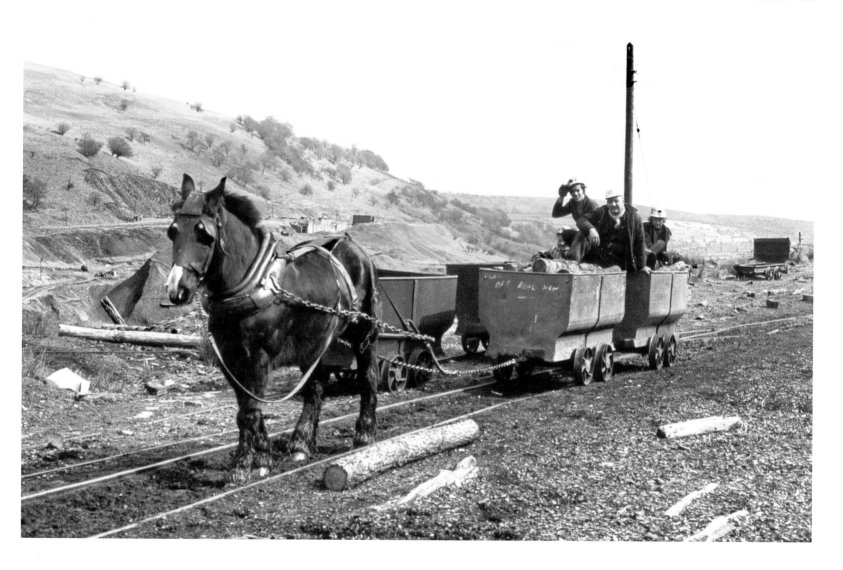

Left: Ruston & Hornsby 2 ft gauge LBT class four-wheel diesel-mechanical *Wendy* (W/No. 432647 of 1959), one of four used at Llewellyn & Wilkins Ltd's private mine at Pen Rhiw Fawr, near Ystalfera, on 27 August 1970. The railway served five working faces located up to 700 metres underground from the adit. (Roy Burt)

Right: By 21 April 1990, the mine was in the ownership of Parc Level Colliery Co. Ltd and *Wendy* was dumped out of use. The private colliery was progressively worked on several levels, with the locos chiefly working underground. This was the first loco purchased by the company, from a Cardiff-based plant contractor in 1962, and it was eventually sold for scrap around the time of the mine's closure in 1993. (Author)

Right: On 28 August 1970, this solitary Hudswell Clarke 0-6-0 saddle tank (W/No. 1562 of 1925) stands abandoned beneath the former Duffryn Rhondda colliery buildings. Although the colliery ceased winding in November 1966, the installation remained open for washing coal until around early 1970. The veteran was eventually scrapped on site during the following April. (Roy Burt)

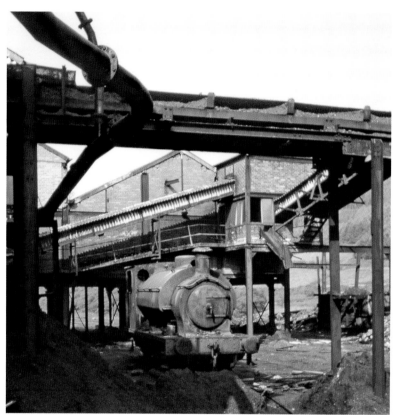

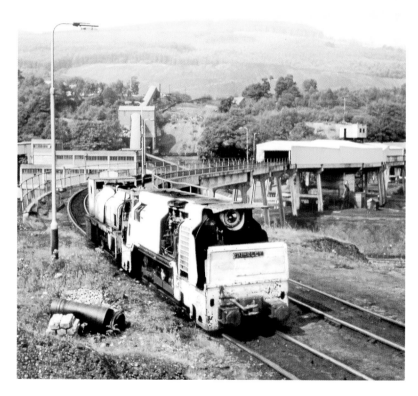

Left: The 2 ft gauge surface and underground system at Blaengwrach colliery, Cwmgwrach, on 29 August 1970, with Hunslet 0-4-0 flameproof diesel-mechanical mines locos 9 (W/No. 3358 of 1945) and 2 (W/No. 6048 of 1961) close to the adit. Opened in 1962, the line ran between the mine and Aberpergwm coal preparation plant and was closed in July 1983. (Roy Burt)

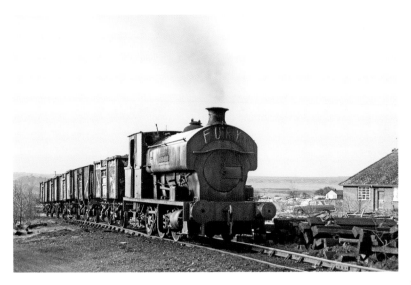

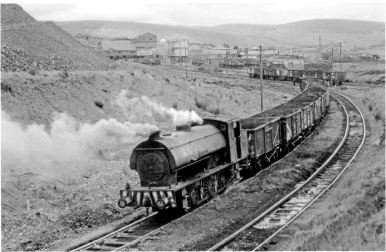

Above left: In the late 1960s, decrepit Avonside 0-6-0 saddle tank *Ton Phillip* (W/No. 1848 of 1920), a one-time veteran of the Maesteg Railways, was eking out the final days of its existence. Nicknamed 'Fury', it was shunting at Wern Tarw, Pencoed, in the Ogmore Vale. Wern Tarw colliery closed in August 1964, but the surface installation was used for the new Coed Cae colliery. The Avonside was scrapped in autumn 1972, when rail traffic ceased, Coed Cae colliery closing in the following September. (Author's collection)

Below left: Maesteg is a large town located at the western edge of the recognised Valleys region. It was one of the larger mining communities in South Wales, with good quality steam coal found relatively close to the surface. In the 1950s, approximately half of the town's population of 23,000 was employed in the industry. The original railway system was built to serve the ironworks at Maesteg and Llynfi Vale, later being extended to the collieries in the area. In later years, until 1973, the extensive system, serving three collieries and a washery, was exclusively steam-worked by a stud of Austerity saddle tanks, with three normally in use daily. The BR exchange sidings were at Llynfi Junction, alongside the ex-GWR Tondu–Abergwynfi line. In February 1969, Hunslet Austerity *Maureen* (W/No. 2890 of 1943 – rebuilt 3882 of 1962) prepares to set back into the Maesteg Central Washery. Built on the site of the old Maesteg Deep colliery, the washery was opened in 1957, despatching most of its small washed coal to the steel works at Port Talbot and Cardiff, as well as for power generation. Diesel locos first arrived in 1973 and one Austerity, *Pamela* (W/No. 3840 of 1956), was retained as a spare engine, but last saw work there in September 1975. Closure of the collieries on the Maesteg system started with Caerau in 1977, followed by Coegnant in 1981, and finally Cwmdu (also known as St John's) in 1985. The washery remained operational until October 1989 whilst coal was recovered from the colliery tips for burning at power stations, but it was not until early 1993 that the final stocks of coal were removed. (Tony Brown)

Opposite page: On 5 May 1975 and during her last year of service at Maesteg, primarily as a standby loco to diesel traction, *Pamela* sets off from Cwmdu colliery with a load for the washery, with Mynydd Llangeinor looming up behind. Originally sunk in 1910 and the last pit to remain on the Maesteg system, it closed in November 1985, a very sad time for its workforce of 1,150. (Author)

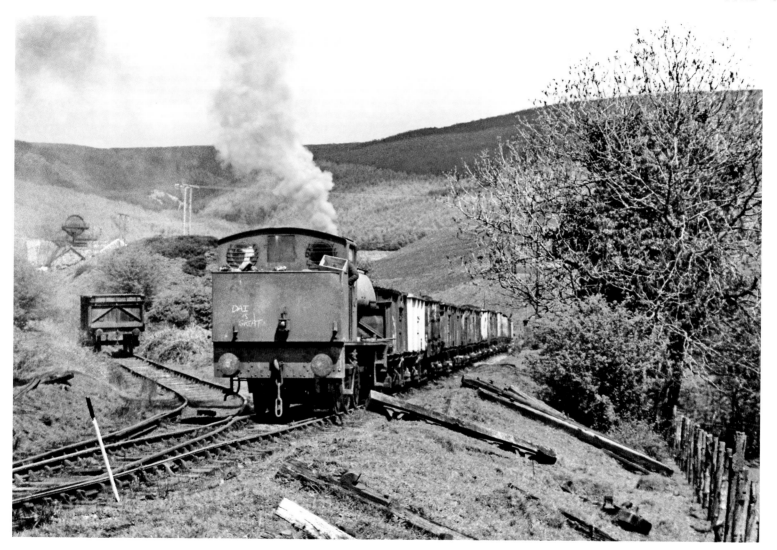

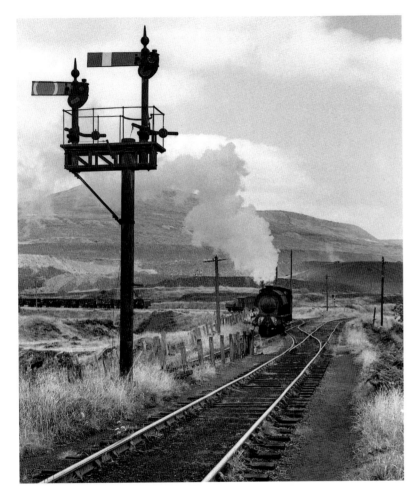

Left: Under a fine but redundant GWR lower quadrant signal bracket on the ex-Port Talbot Railway track, this William Bagnall Austerity 0-6-0 saddle tank (W/No. 2766 of 1944) heads from the Maesteg Railways loco shed to one of the northern pits on 5 September 1972. Bearing no name, it was referred to simply as 'NCB', which it carried on its saddle tanks. The 1,182-foot-high Garn Wen mountain looms up behind the signals. (Richard Stevens)

Opposite page: Hunslet Austerity *Maureen* propels a load of 16-ton wagons up to the Maesteg Central Washery on 15 April 1971. The severity of the gradient was increased by the incorporation of a wagon traverser into the washery's layout, ensuring that the locos always had to work flat out on this duty. Indeed, it was a paradox that locos with names such as *Patricia*, *Linda*, *Norma*, *Pamela* and *Maureen* went about such arduous tasks. (Richard Stevens)

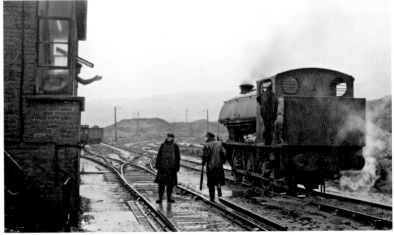

Right: The drenched crew of Hunslet Austerity *Norma* (W/No. 3770 of 1952) receive instructions from the Central Washery weighbridge controller at Maesteg on a thoroughly wet day in February 1969. (Tony Brown)

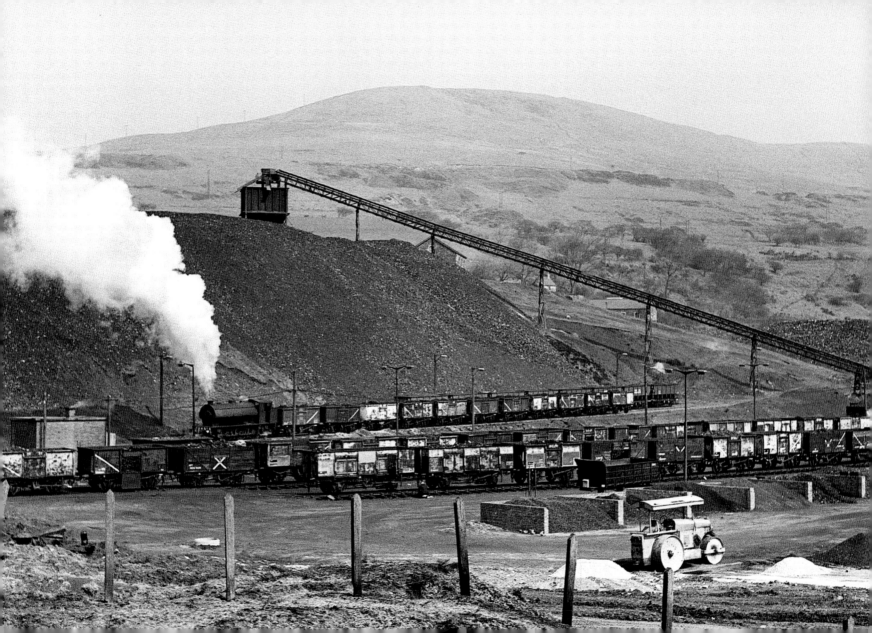

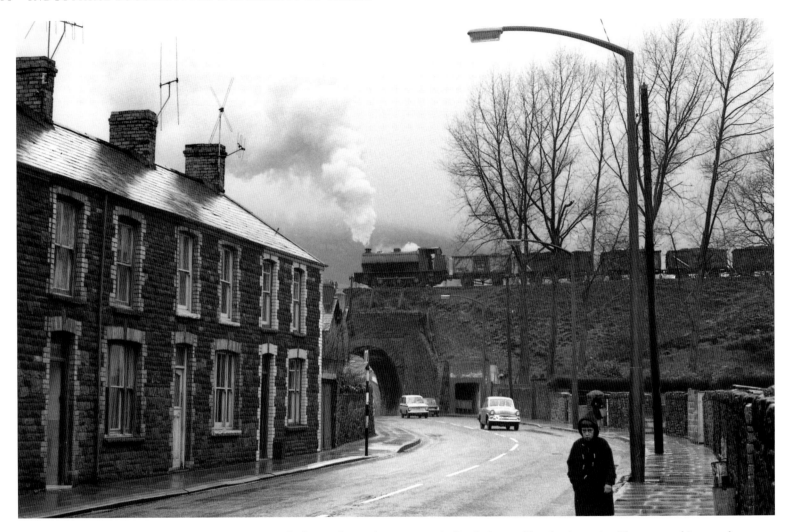

A scene on a wet day in February 1969, looking towards the road tunnel on Maesteg's Castle Street. Hunslet Austerity *Norma*, working on the truncated remnant of the former Port Talbot Railway, pushes back a loaded train towards the Central Washery, with coal from Cwmdu colliery. (Tony Brown)

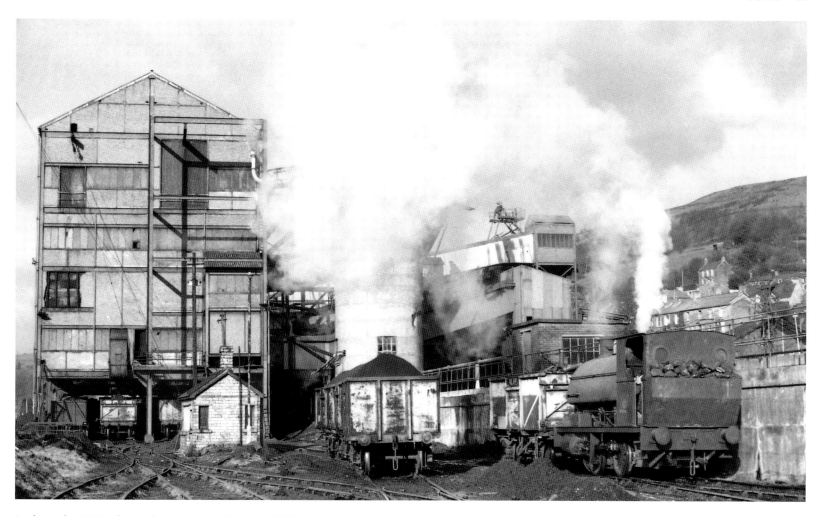

In the early 1970s, this Peckett 0-4-0 saddle tank (W/No. 1676 of 1925) shunts the Tymawr & Lewis Merthyr colliery, which was located a mile north-west of Pontypridd station. With the arrival of diesel traction, the W5 class Peckett fell into disuse by 1974 and was scrapped in March 1976. The last coal was wound on 21 June 1983, and the colliery was demolished shortly thereafter. (Tony Brown)

Above: Peckett 0-6-0 saddle tank *Mardy No. 1* (W/No. 2150 of 1954) in the exchange sidings at Mardy colliery, Maerdy, in April 1974. It was one of two identical OQ class locos supplied to the NCB in 1954 for working the severe gradient from the BR exchange sidings to the colliery at the head of the Rhondda Valley. Its sister was scrapped in 1968, and the remaining Peckett became affectionately known as the 'Mardy Monster'. It was in steam due to the failure of both the resident diesel and the ex-BR Class 11 diesel, which had been hired in from specialist dealer A. R. Adams of Newport. It proved to be a bad day for the colliery, as the washing plant had also failed, resulting in no work for the loco. The driver had optimistically assured the photographer that it would be working the following day. A return visit proved otherwise, for it was found securely locked in the loco shed! (John Brooks)

Opposite page: On a dismal day in February 1970, former BR pannier tank No. 9792, with badly leaking steam, struggles near the weighbridge with a rake of empties for Mardy colliery. (Colour-Rail)

Below: Ruston & Hornsby flameproof 48DLG class four-wheel diesel-mechanical 521/2034 (W/No. 451904 of 1962) working the 2 ft 5 in. gauge stockyard system at Tower No. 4 Shaft, Hirwaun, on 26 August 1970. This surface system was used between circa 1967 and 1986. (Roy Burt)

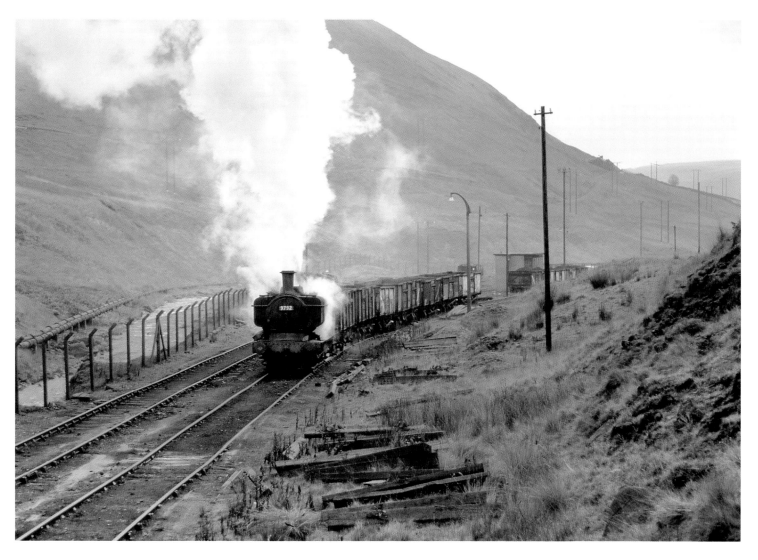

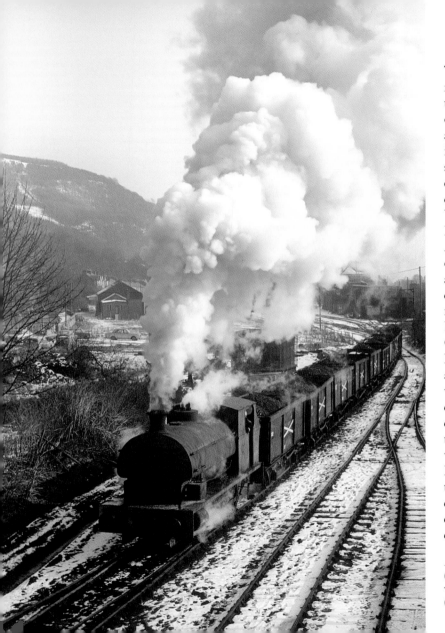

The Mountain Ash system was arguably the most well-known of all NCB railways in Wales, possibly influenced by having in the early 1970s one of the last two working examples in industry of the once numerous 5700 Class of pannier tanks. The system's two-road loco shed housed up to six locos and had full-length inspection pits. Situated alongside the River Cynon, it was approximately mid-way on the system between Pont Cynon in the south and Aberaman in the north. The nearby A4059 road bridge afforded excellent views of the shed area when looking south, and of Deep Duffryn colliery and washery on its north side. It spanned both the former Taff Vale Railway route and the NCB running lines on the route of the former BR Vale of Neath line. From 1974, the NCB conveyed coal directly to the Aberaman Phurnacite plant at Abercwmboi from a new loading hopper opposite Penrhiwceiber town. It was fed directly by overhead conveyor across the Cynon river from Penrikyber colliery and initially enabled the cessation of most BR services for this output. During the 1970s, the shed maintained a varied fleet where, in addition to pannier tank No. 7754, could be found examples from Peckett, Avonside, Andrew Barclay and Hudswell Clarke, as well as an Austerity saddle tank built by Robert Stephenson & Hawthorns. All locos were six-coupled by necessity for their arduous tasks and usually three were steamed daily in the 1970s. However, the writing was on the wall for the system when Deep Duffryn colliery wound its last coal in September 1979, after almost 130 years of production. The washery continued in use for incoming coal delivered by BR until September 1980, the time when regular steam working ceased. From thereon, diesel traction, with two steam locos held in reserve, handled movements between the Penrikyber loader and Aberaman until April 1981. Following damage to the Cynon river bridge at Abergorki in devastating floods, the NCB line was consequently abandoned, and BR was once again called upon to convey coal between Penrikyber colliery and the Phurnacite plant until the colliery closed in 1985, followed by the Phurnacite plant in 1990.

Left: On 17 February 1978, Peckett OX1 class 0-6-0 saddle tank *Sir Gomer* (W/No. 1859 of 1932) is seen with a rake of mainly 20-ton capacity internal wagons of coal for the Phurnacite plant from the Penrikyber colliery loader. (John Brooks)

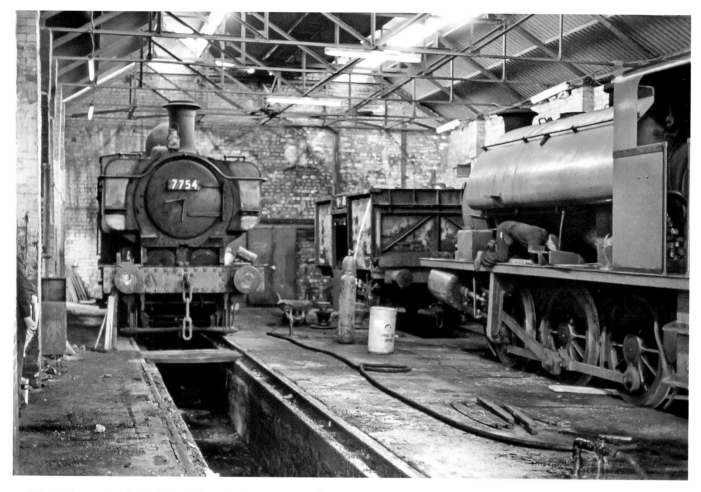

On 28 June 1972, Hudswell Clarke 0-6-0 saddle tank (W/No. 1885 of 1955) receives attention from a fitter inside Mountain Ash loco shed. Alongside is No. 7754, at this time held in reserve and not a favourite with the crews there. The former BR loco entered service at Mountain Ash in May 1970, but was destined to be permanently out of use from around 1975. (Author)

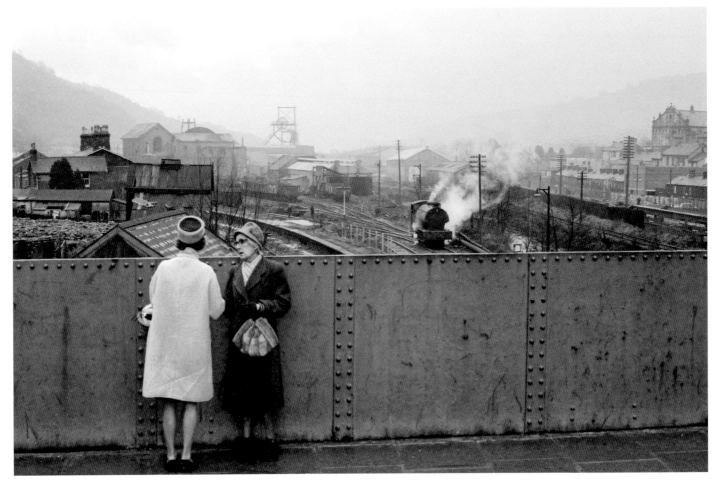

A conversation takes place on the A4059 road overbridge at Mountain Ash in the early 1970s, whilst in the background Robert Stephenson & Hawthorns Austerity 0-6-0 saddle tank No. 8 (W/No. 7139 of 1944) simmers between duties in the sidings alongside the former GWR/BR Cardiff Road (Vale of Neath) station platforms, abandoned since 1964. Beyond and to the right is the system's loco shed and the Abergorki colliery site, some buildings by then being used for central stores and workshops purposes. (Tony Brown)

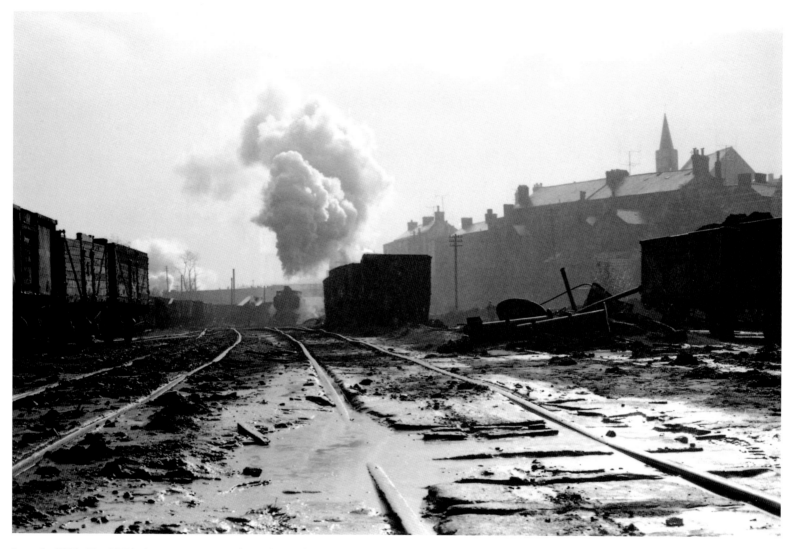

In early 1970, No. 7754 claws its way over the inebriated and waterlogged trackwork at Deep Duffryn colliery. (Tony Brown)

Right: Early on the morning of 7 September 1979, Andrew Barclay 0-6-0 saddle tank *Llantanam Abbey* (W/No. 2074 of 1939) slips violently on the wet rails while shunting the holding sidings south of the closed Abergorki colliery. (Author)

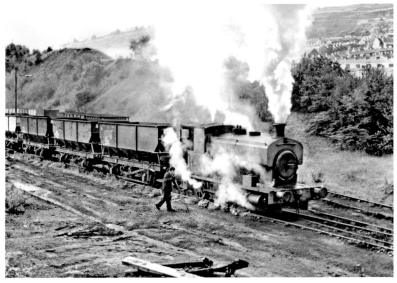

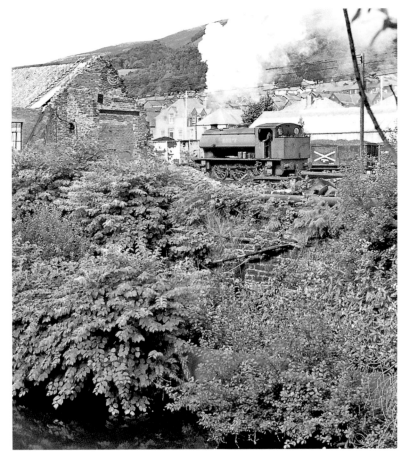

Left: On 7 September 1979, Austerity 0-6-0 saddle tank No. 8 shuffles past the rear of the shed at Mountain Ash, glimpsed across the murky Cynon river, which just over a year later influenced the demise of the NCB operations based at Mountain Ash. (Author)

Opposite page: Peckett 0-6-0 saddle tank *Sir Gomer* shunting the Cwm Cynon coal stocking site near Penrhiwceiber on 5 May 1975. This stockpile was established on the site of the former Cwm Cynon colliery, which had closed in 1949. Coal not immediately required for despatch was deposited here and graded by size into separate stockpiles. Much of this operational reserve of low grade 'duff' and 'raw small' coal would almost inevitably be transported to the Phurnacite plant upon demand. *Sir Gomer* was a popular loco with Mountain Ash drivers. It had given its entire industrial service life to Mountain Ash and was one of the last active locos there, having benefitted from a heavy overhaul at the NCB's Walkden workshops in Lancashire in the early 1970s. (Author)

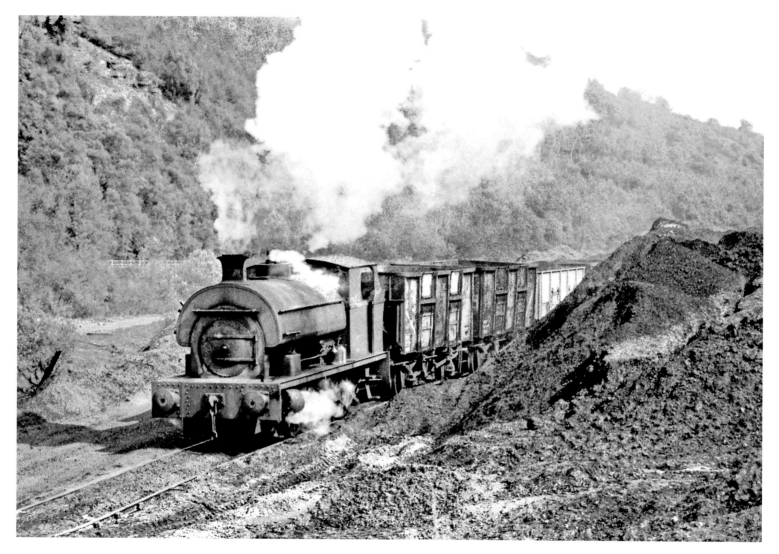

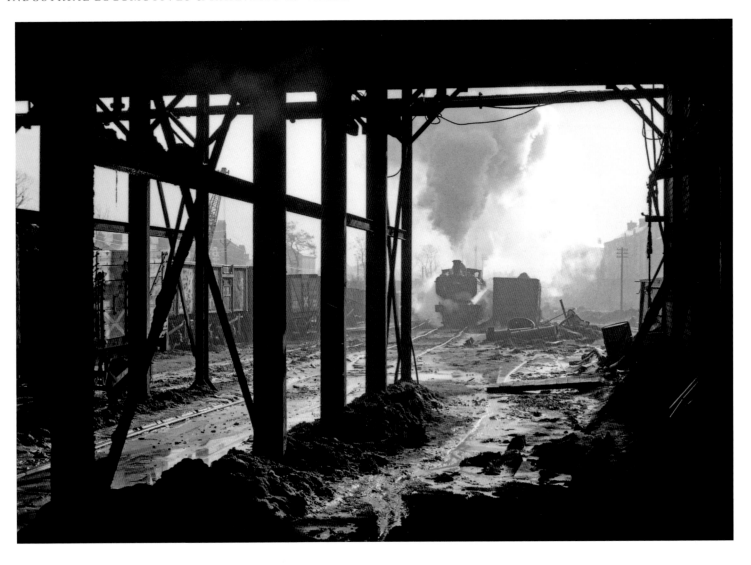

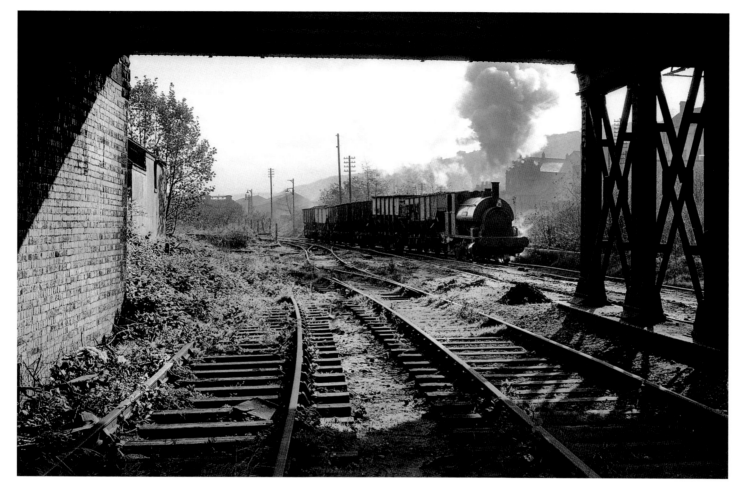

Above: Veteran Avonside 0-6-0 saddle tank *Sir John* (W/No. 1680 of 1914) trundles along the main running line towards the junction with Deep Duffryn colliery with a rake of loaded BR hopper wagons in early 1970. (Tony Brown)

Opposite page: In early 1970, No. 7754 approaches the Deep Duffryn colliery loading screens. (Tony Brown)

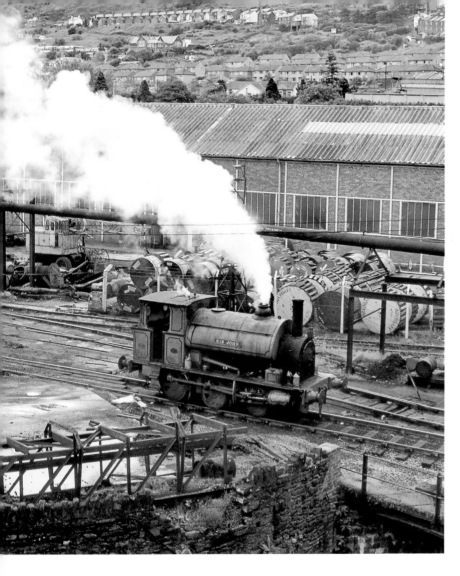

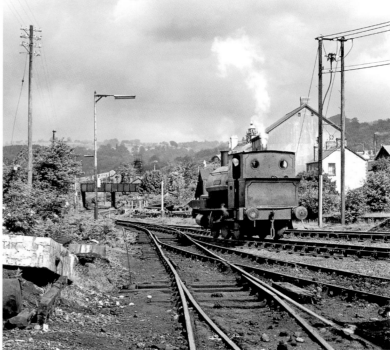

Left: On 28 June 1972, the venerable Avonside *Sir John* stands outside the Central Workshops at Abergorki, alongside the Afon Cynon bridge, waiting impatiently for its afternoon shunting duties around Mountain Ash and Deep Duffryn and (above), after the shift change, heading off to Deep Duffryn colliery just ahead of a heavy downpour. Flood damage to this Cynon river bridge sadly resulted in the closure of the system in 1981. (Both author)

Opposite page: On a winter's day in early 1972, *Sir John* was undertaking a regular duty, that of shunting Deep Duffyn colliery. (Author's collection)

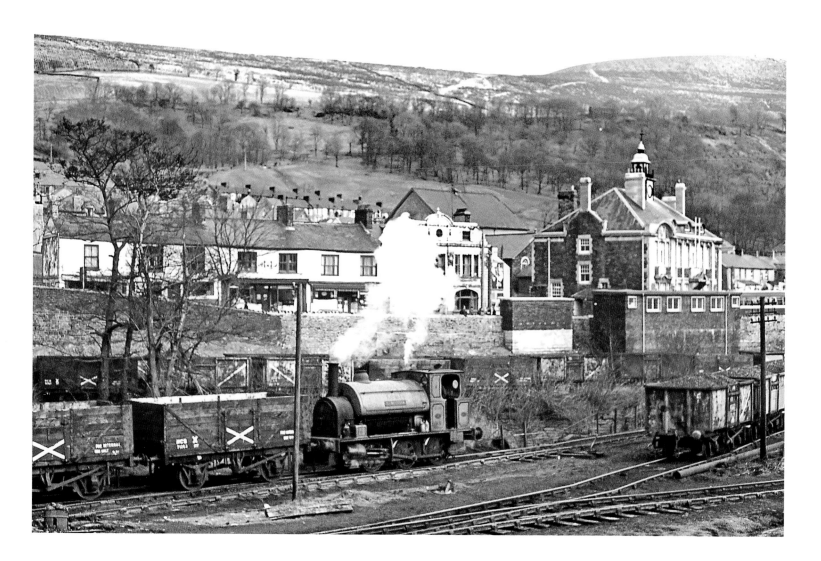

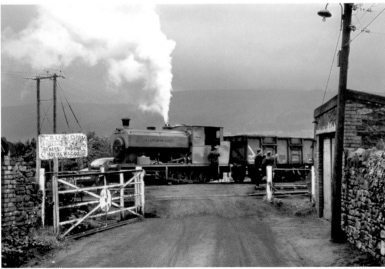

The Deep Duffryn washery shunt was a key task for Mountain Ash locos. It was from here that internal wagons of 'duff' would be taken the short distance north to Bruce's Field sidings, then trip-worked to the Aberaman Phurnacite plant at Abercwmboi. This extensive plant was also supplied by BR with output from collieries further south down the valley and beyond. Coal was also provided by Aberaman colliery until its closure in 1962, although a washing facility continued in use there until early 1971, worked by Mountain Ash locos. The BR/NCB exchange yard east of Aberaman town was also a key location for satisfying some of the Phurnacite plant's consumption. The plant had commenced production in 1939 under the ownership of the Powell Duffryn Company and it compressed small coal and 'duff' into Phurnacite, using a mechanical and chemical process. The resultant egg-shaped product became popular as a household smokeless fuel. In order to produce these 'eggs', the plant paradoxically released toxic sulphurous smoke and fumes into the atmosphere all year round, until production ceased in March 1990. When BR officially abandoned the remaining section of the Vale of Neath line north from Mountain Ash (Cardiff Road) to Aberdare (High Level) on 29 November 1971, the NCB acquired the use of this relatively well maintained line to convey locally mined volume to the Phurnacite plant. A new weighbridge was installed adjacent to the former Cardiff Road station to monitor the volumes despatched to the plant from 1974. From February 1971, Mountain Ash provided the plant with shunting locos, which had previously been maintained at Aberaman colliery loco shed. This arrangement continued until the rail link from Mountain Ash was forced to close in 1981, following damage to the Cynon river bridge adjacent to the NCB Area Workshops and the former Abergorki colliery.

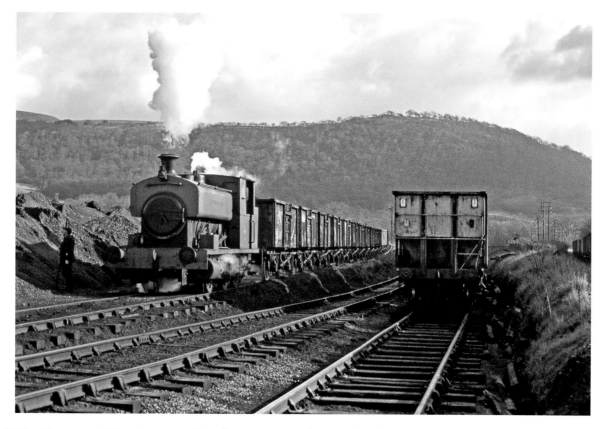

Above: In the mid-1970s, *Llantanam Abbey* is seen working the extensive yard serving the Phurnacite plant, the sidings containing several rakes of wagons either deposited or awaiting collection by BR. (Author's collection)

Opposite page above and below left: Andrew Barclay *Llantanam Abbey* shunting the Aberaman stocking ground on 7 July 1974. Originally entering service at Penrikyber colliery, this chunky Andrew Barclay 0-6-0 saddle tank was registered by the GWR in 1944 to work over the metals of the former Taff Vale route between Penrikyber colliery and Aberdare. It was transferred to Mountain Ash from Aberaman loco shed in 1964. Its name was incorrectly applied when it emerged from Walkden Central Workshops in September 1971, and so it remained throughout the rest of its NCB service, never being corrected to Llantarnam Abbey, which it had hitherto carried. (Author's collection)

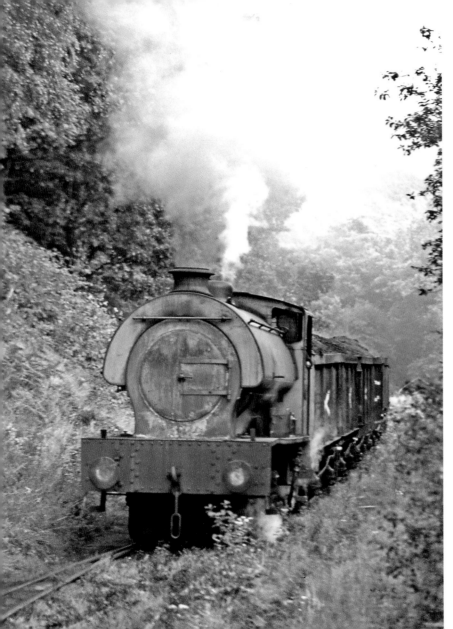

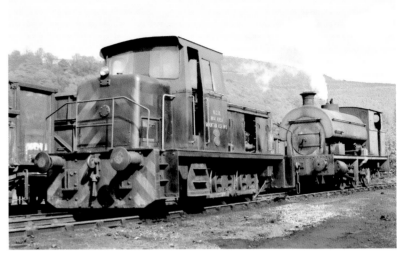

Left: On the sultry afternoon of 7 September 1979, two weeks before the closure of Deep Duffyn colliery, and in the eleventh hour for regular steam traction use on the Mountain Ash system, Austerity 0-6-0 saddle tank No. 8 storms purposefully along overgrown track on the sharp climb between Pont Cynon and Cwm Cynon with loaded internal user wagons of 'duff' originating from Penrikyber colliery, destined for consumption at the voracious Phurnacite plant. (Author)

Above: On 5 May 1975, Andrew Barclay 0-6-0 diesel-hydraulic *Mountain Ash No. 5* (W/No. 495 of 1964) breaks away from its duties at the Phurnacite plant and meets up at shift change, alongside Mountain Ash shed, with Peckett *Sir Gomer*. Four of these 455 hp diesel-hydraulics were supplied new in 1964 to Aberaman Railways, maintained at Aberaman loco shed until 1971, specifically for shunting the Phurnacite plant. No. 5 was in a dismantled condition within two years of the author's visit, and was scrapped at Mountain Ash during 1980. (Author)

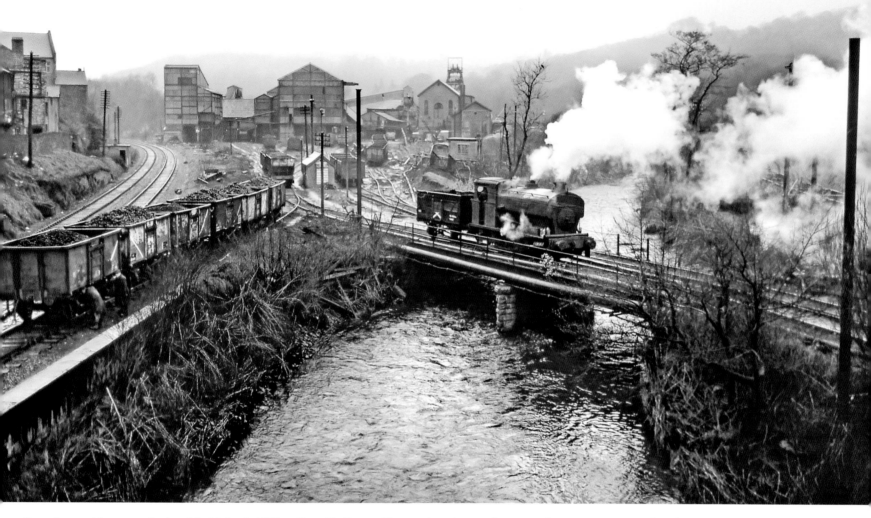

On a thoroughly wet and miserable 16 April 1970 at Deep Duffryn colliery and washery, a fitter attends to a wagon in a rake of loaded BR 16-ton wagons fouling what was the down line of the former TVR Aberdare branch, by this time an NCB siding. Avonside 0-6-0 saddle tank *Lord Camrose* (W/No. 2008 of 1930) waits patiently on the Cynon river bridge with an internal wagon, ready to resume its shunting duties. (Author's collection)

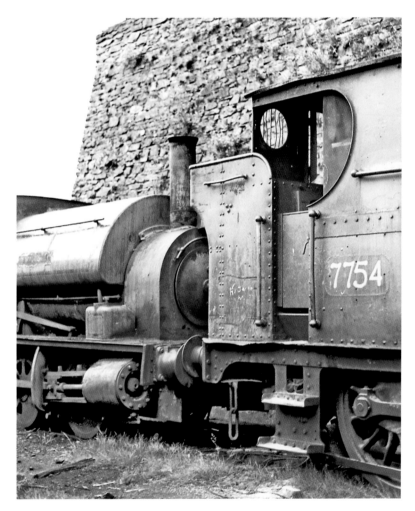

Left: Their working days in industry were over by 7 September 1979 for pannier tank No. 7754 and Avonside *Sir John*, both by this time set aside at Abergorki for eventual preservation (Author)

Above: In the shadows of the closed Navigation & Abergorki colliery, North British four-wheel diesel-hydraulic MT *Ash No. 1* (W/No. 27545 of 1959) and English Electric Stephenson Works 0-4-0 diesel-hydraulic *ACN No. 1* (W/No. 8426 of 1963) were dumped outside the Central Workshops on 7 September 1979. The low profile 180 hp former North British demonstrator loco had arrived at Mountain Ash from Taff Merthyr colliery in summer 1977, but saw either little or no use and was scrapped during summer 1980. The 262 hp English Electric, a one-time Abercynon colliery shunter, was equally unfortunate; after assessment at BR Canton depot in autumn 1974, it was condemned and subsequently taken to Mountain Ash to provide spares. It survived in an increasingly dismantled state until finally meeting its fate in October 1982. (Author)

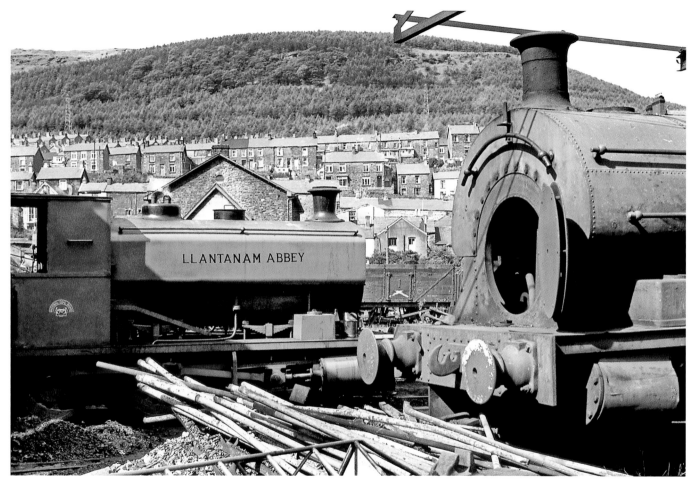

Peckett B2 class 0-6-0 saddle tank *The Earl* (W/No. 1203 of 1910) dumped beneath what was the coal stage shelter outside Mountain Ash shed on 28 June 1972, with *Llantanam Abbey* simmering between duties behind. *The Earl* had been supplied new to Welsh Associated Collieries Ltd at Tower colliery and arrived at Mountain Ash as early as 1932. It was disposed of for scrap during the summer of 1973. *Llantanam Abbey* continued to soldier on, passing into preservation almost a decade later, in February 1982. (Author)

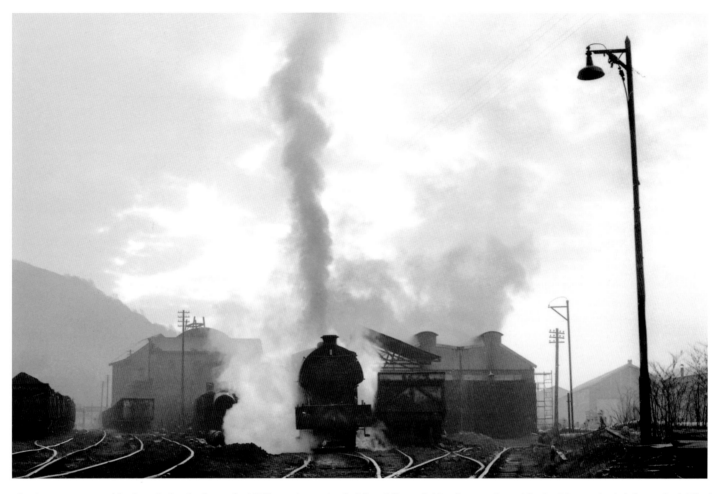

An atmospheric scene on a cold winter's day in the early 1970s, as Austerity 0-6-0 saddle tank No. 8 runs alongside the Mountain Ash loco shed. The buildings in the background to the left are those of Navigation & Abergorki colliery, closed in 1967. The rare and distinctive 40-foot diameter Waddle rotary fan protrudes above the roofline. (Tony Brown)

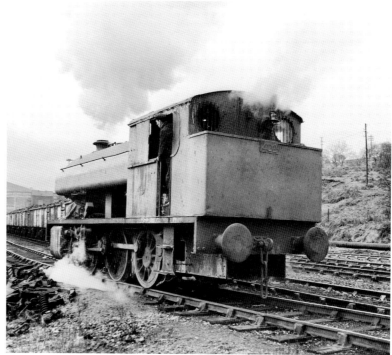

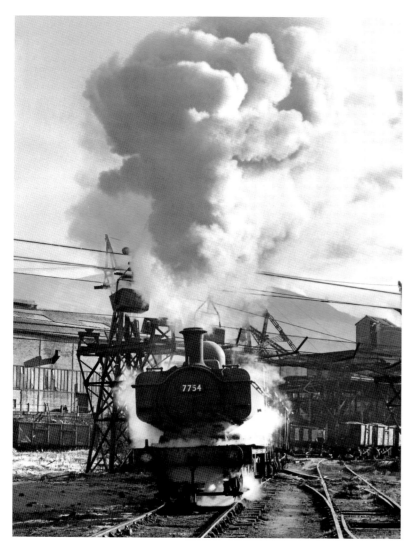

Above: William Bagnall 0-6-0 saddle tank 402 (W/No. 2995 of 1951), shunting Ogilvie colliery in 1964. This powerful 18 in. × 26 in. cylinder loco, one of three originally purchased new by the Steel Company of Wales at Port Talbot, incorporated a whole range of advanced features including Walschaerts valve gear, mechanical lubricators, roller bearings, rocking grate and a self-cleaning smokebox. Acquired by the NCB in 1961, it was scrapped as early as April 1967, after working at Groesfaen colliery for a short period from summer 1965. (A. E. Durrant – Author's collection)

Left: In early 1971, No. 7754 is seen hard at work with loaded BR 16-ton wagons at the north end of Deep Duffryn colliery, passing beneath the overhead drag line. (Tony Brown)

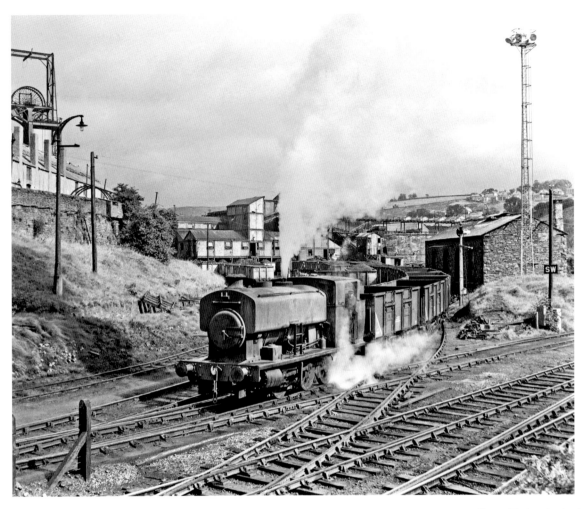

Andrew Barclay 0-6-0 saddle tank 2 (W/No. 2339 of 1953) shunting empty 16-ton wagons at Deep Navigation colliery, Treharris, in August 1963. Supplied new to the colliery, it was scrapped on site in summer 1969. The unusual colliery name had its origins in an Admiralty report of 1851 recommending that its best quality steam coal was suitable for shipping purposes. (A. E. Durrant – Author's collection)

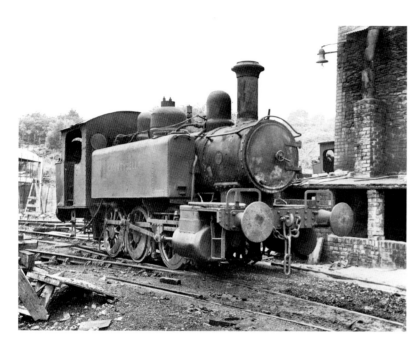

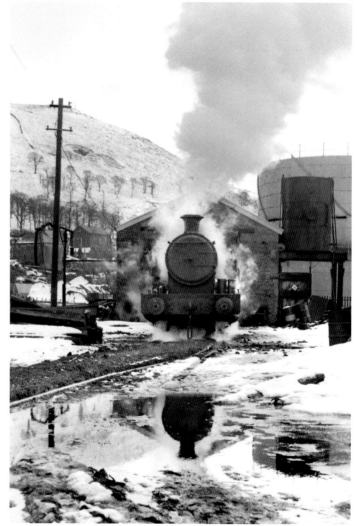

Above: Baldwin 0-6-0 pannier tank *Courtybella* (W/No. 46351 of 1917) at Cwm colliery, Llantwit Fardre, on 6 July 1952. Originally No. 653 in the wartime Railway Operating Department fleet, it was used at Central Supply Depot 311 at Hackney Mashes. After hostilities ended, it was acquired in 1923 by the Whitehead Iron & Steel Co. Ltd for their Courtybella works. Acquired by the NCB in summer 1950, it thereafter worked at Risca, Coed Ely, Cwm and Lady Windsor collieries. It was withdrawn from service in 1954 and scrapped at Llwynpia Central Workshops in August 1955. (Bernard Roberts – IRS collection)

Right: Less than 2 miles east from Mountain Ash as the crow flies, over the 1,500-foot Mynydd Merthyr and in the high reaches of Taff Vale, was Merthyr Vale colliery at Aberfan. On a chilly morning in early 1970, Andrew Barclay 0-6-0 tank No. 1 (W/No. 2340 of 1953) moves off shed to take up its day's duties. (Tony Brown)

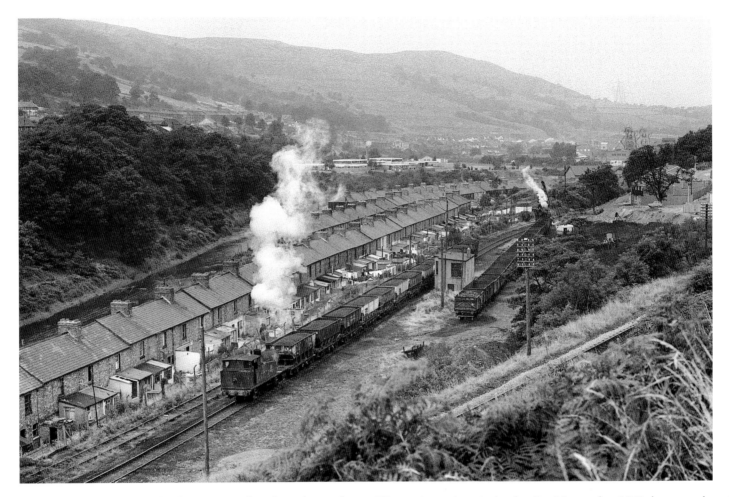

Merthyr Vale was one of a handful of collieries in South Wales to have a former BR pannier tank on its books. On 6 September 1972, however, the colliery's six-coupled Peckett and Andrew Barclay locos were to be found in action. The latter loco, No. 1, hauls a rake of loaded hopper wagons up to the exchange sidings, with the Peckett following up behind to provide banking assistance. No. 1 was scrapped on site three years later, upon dieselisation of the colliery shunting and transfer duties. The terraced houses of Taff Street and Crescent Street are typical of mining communities in the Welsh Valleys. (Richard Stevens)

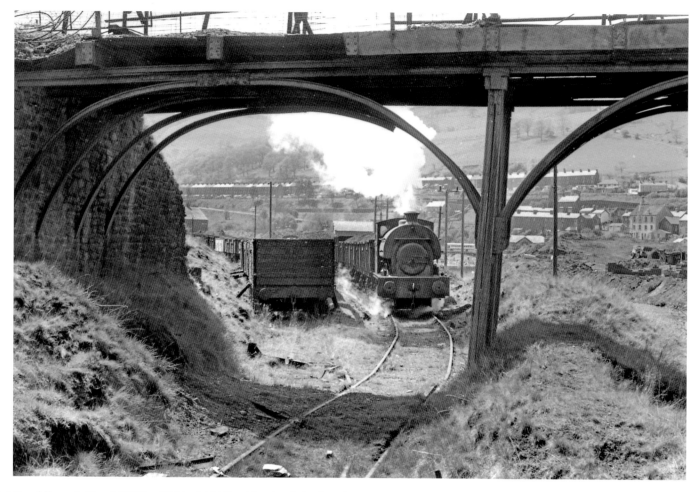

Peckett 0-6-0 saddle tank No. 6 (W/No. 2061 of 1945) with a loaded rake of BR 16-ton wagons at the north end of Merthyr Vale colliery in the early 1970s. The adjacent town of Aberfan was the scene of the tragic disaster in October 1966, when coal slurry slid down the hillside from a spoil tip, engulfing Pantglas junior school and adjoining buildings, resulting in the death of 116 children and twenty-eight adults. Only after protracted wrangling by Aberfan residents were the remaining tips removed. Merthyr Vale colliery closed in August 1989. (Tony Brown)

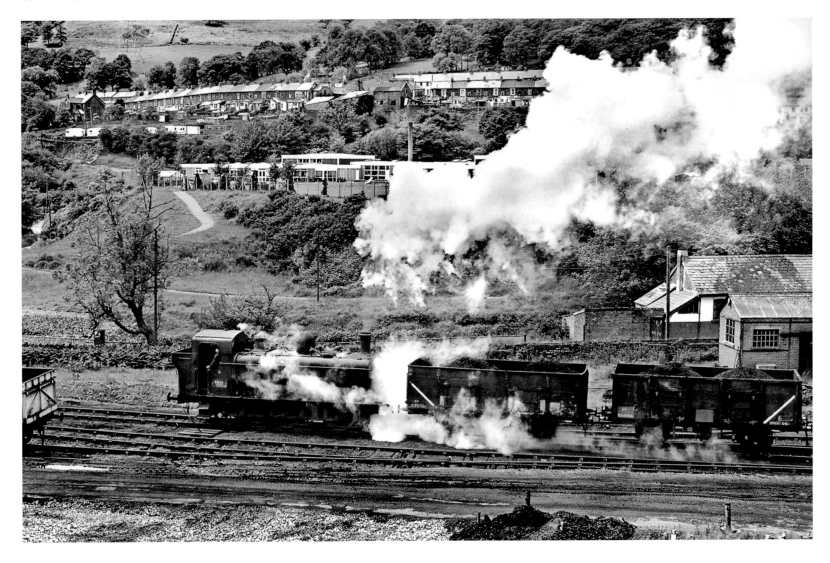

Opposite page: On 28 June 1972, ex-GWR/BR 5700 Class 0-6-0 pannier tank No. 9600, built at Swindon works in 1945, lifts a loaded train out of Merthyr Vale colliery yard, destined for the BR exchange sidings. No stranger to the Welsh Valleys in the latter period of its BR career, it had been allocated to Aberdare and Neath depots between October 1962 and November 1964. Withdrawn from BR service at Newport Ebbw Junction shed in September 1965, it was immediately purchased by the NCB. It deservedly passed into preservation in August 1973, moving via BR Canton depot to Tyseley, and it is now in the care of Vintage Trains at the Tyseley Locomotive Works. (Author)

Right: A worker gets a lift over the flooded stockyard at Nantgarw colliery on 21 August 1970, with a 3 ft gauge Ruston & Hornsby 48DL class (W/No. 339214 of 1952) doing the honours. Behind is a 48DLU class (W/No. 296056 of 1950). (Roy Burt)

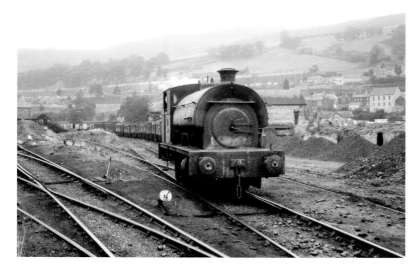

Left: The woebegone Merthyr Vale colliery's OX3 class Peckett, rebuilt by William Bagnall in 1962, standing between duties in the colliery yard on a wet and murky 4 September 1972. Delivered new in 1945 to Slough Estates Ltd, as No. 6 in their fleet, its long wheelbase proved to be unsuitable for the trading estate railway, so it was sold to the NCB in 1949. It spent time at Aberaman and Mountain Ash before being transferred to the adjacent valley to the east during the winter of 1962–63. After a decade of demanding tasks in the Taff Vale, it was despatched in July 1974 to BR Canton depot for much needed tyre re-profiling, but work was abandoned upon discovering the loco's poor overall condition. With two former BR 08 Class locos by then undertaking the work at Merthyr Vale, the decision was taken to immediately send it for scrap, to the Pontypool Road yard of W. James Harris. (John Sloane)

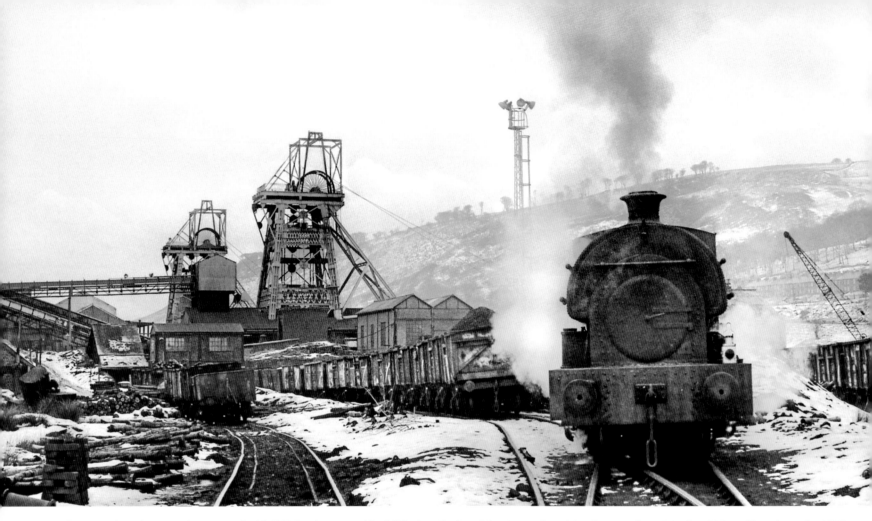

Above: With a dusting of snow in the Taff Vale, the venerable OX3 class Peckett No. 6 was found hard at work at Merthyr Vale colliery in early 1971. (Tony Brown)

Opposite page: Andrew Barclay 0-4-0 saddle tank *Lily No. 8* (W/No. 1608 of 1918) raising the echoes at Celynen South colliery, Abercarn, in 1970. Diesel traction took over soon after this and she was scrapped in May 1972. The colliery closed in September 1985. (Tony Brown)

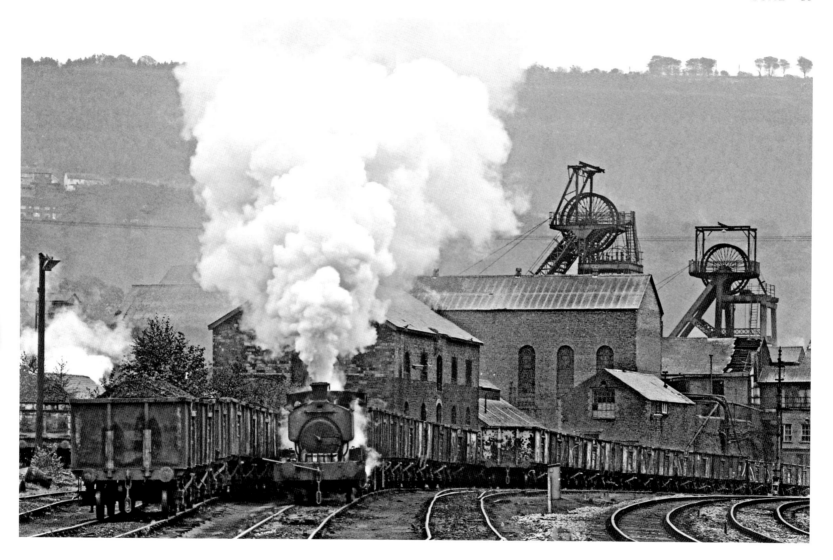

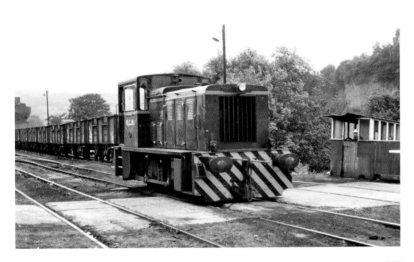

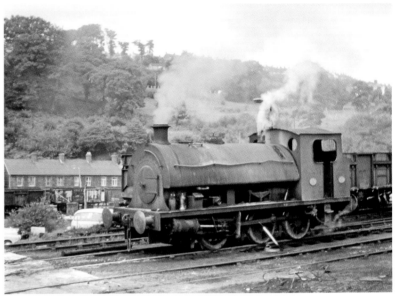

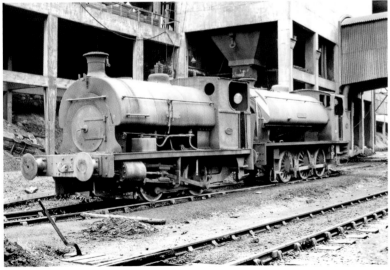

Above left: A North British 225 hp 0-4-0 diesel-hydraulic (W/No. 28039 of 1961) at Celynen North colliery on 4 September 1972. (John Sloane)

Above: Hawthorn Leslie 0-6-0 saddle tank 58 (W/No. 3923 of 1937) brewing up between duties at Celynen North colliery on 18 August 1970. The Ebbw Vale colliery closed in August 1989. (Roy Burt)

Left: Hafodyrynys colliery on 28 June 1972, with 0-4-0 saddle tank No. 31 *Sir Charles Allen*, a hybrid loco rebuilt in 1967–68 using parts of Ebbw Vale Steelworks (W/No. 2) and two Peckett locos (W/Nos 1465 and 1524), the frame believed to be that of Peckett W/No. 1465 of 1917. Standing behind is Hunslet Austerity *Glendower* (W/No. 3810 of 1954), both locos revealing some signs of their former glory through the grime. (Author)

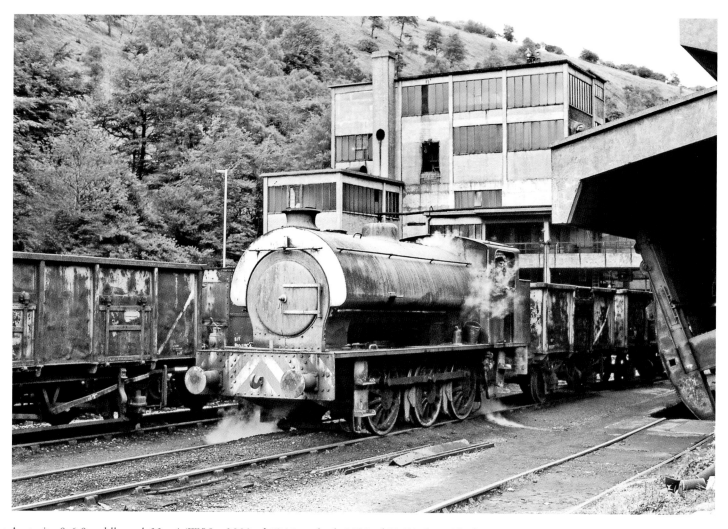

Hunslet Austerity 0-6-0 saddle tank No. 4 (W/No. 2893 of 1946 – rebuilt 3881 of 1962) alongside the rotary coal tippler at Hafodyrynys colliery on 28 June 1972. The colliery and washery closed in 1975 and 1978 respectively. (Author)

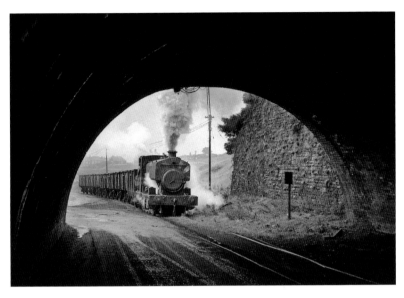

Above: In 1879, when the Monmouthshire Railway & Canal Company (soon to be absorbed by the GWR) extended its network northwards to make an end-on connection with the LNWR at Abersychan & Talywain station, it had to incorporate a large arch into the high curved embankment it constructed a few hundred yards south of this station. The purpose of the arch was to bridge an industrial line which served both coal and iron industries, with the British Ironworks (named after the nearby village) lying just to the west of what quickly became known as Big Arch. When the last part of the iron works closed in 1881, locos continued to be based here to serve the local collieries, at what became known as Talywain loco shed. The last colliery to remain open on this system was Blaenserchan colliery, high up in a remote valley, and reached by a scenic, steeply graded and sinuous 3-mile line, which achieved modest fame in the late 1960s as it was often worked by ex-BR pannier tank No. 7754. Blaenserchan colliery ceased winding coal in 1970 and No. 7754 was transferred to Mountain Ash. The only remaining work at Talywain thereafter was traffic between the BR exchange sidings and the landsale

yard near the loco shed, for which a couple of chunky Barclay six-coupled saddle tanks were retained until May 1974. *Islwyn* was the duty loco on the wet morning of 7 September 1972, and is seen here pulling forward with a rake of empties, framed in the Big Arch. The line beyond *Islwyn* and its train had once linked with the ex-GWR line about half a mile from this point at Pentwyn Junction, but by now this part of the line was used simply as a headshunt, allowing reversal between the lines into the yard and the former line to Blaenserchan colliery, part of which was still in use to access the BR exchange sidings. Empty wagons from the landsale yard would also be allowed to roll down here under gravity for collection by the loco the following day; by this stage, the loco only worked for two hours every morning. (Richard Stevens)

Opposite page: Less than 5 miles north of Talywain was Blaenavon, at the eastern edge of the Welsh Valleys, near the head of the Afon Lwyd. It was one of the earliest centres of the Industrial Revolution in Wales and has latterly been described as one of the finest examples in the world of a landscape created by coal mining and ironmaking in the late eighteenth and nineteenth centuries. The Blaenavon Company owned everything in the area, not just the iron and steel works and the collieries, but also the associated iron ore mines and limestone quarries, brickworks, watercourses and workers' houses. However, in the first half of the twentieth century iron and steel making declined while coal production increased, so by the time the coal industry was nationalised in 1947 the company was principally a coal mining concern, and its assets naturally passed to the NCB, including the steam locos used to shunt the collieries in the area, three of which – all Barclay 0-4-0 saddle tanks – survived into the 1970s. On 7 September 1972, Andrew Barclay *Blaenavon Nora No. 5* (W/No. 1680 of 1920) sets off from Big Pit with three loaded wagons for the coal stocking site. The covered conveyor belt took coal from Big Pit to the washery, while the redundant bridge framing the scene once carried tracks to Forgeside furnace tops, transporting the raw materials with which the furnaces were charged. A greatly sanitised version of the scene still exists today; the covered conveyor belt is long gone, as is the spoil tip behind the colliery buildings, now preserved as the Big Pit Mining Museum, and today's Big Pit station of the heritage Pontypool & Blaenavon Railway (P&BR) is to the right of where the left abutment once stood. More about Blaenavon follows on pages 96 and 97. (Richard Stevens)

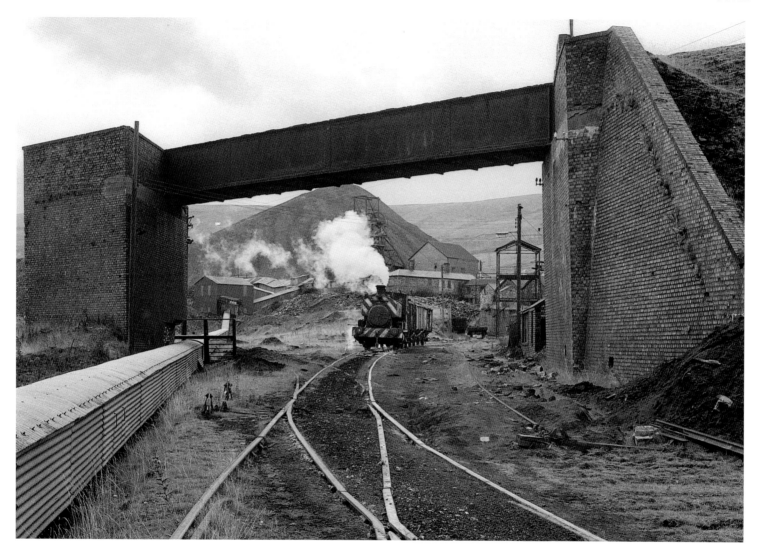

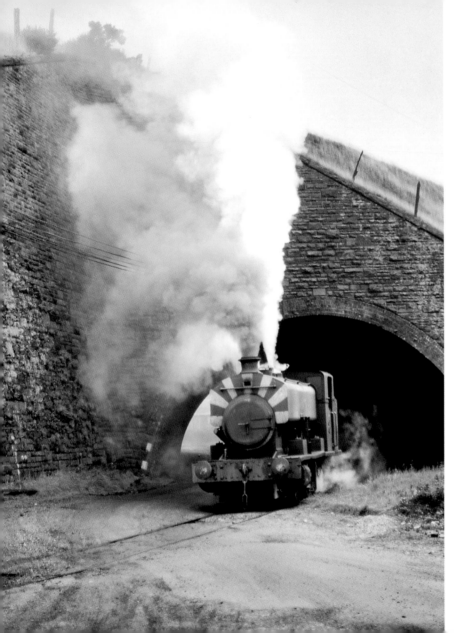

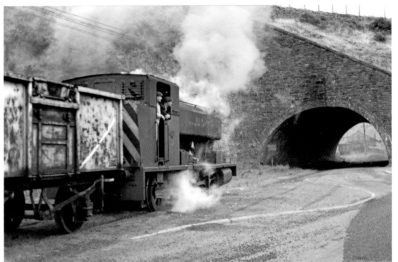

Left: Returning down the valley again to Talywain, Andrew Barclay 0-6-0 saddle tank *Islwyn* (W/No. 2332 of 1952) struggling to move a heavy train through the Big Arch at Talywain colliery, near Pontypool, in October 1971. (Author's collection)

Above: *Islwyn* entering Big Arch on 4 September 1972. (Author's collection)

Opposite page: In June 1967, Andrew Barclay 0-6-0 saddle tank *Illtyd* (W/No. 2331 of 1952) with the Blaenserchan miners' train near Castle Pond sidings, which were adjacent to the site of the Abersychan & Talywain station. The vans are ex-BR Western Region fruit vans and the service usually ran three times per day to coincide with shift changes. (Author's collection)

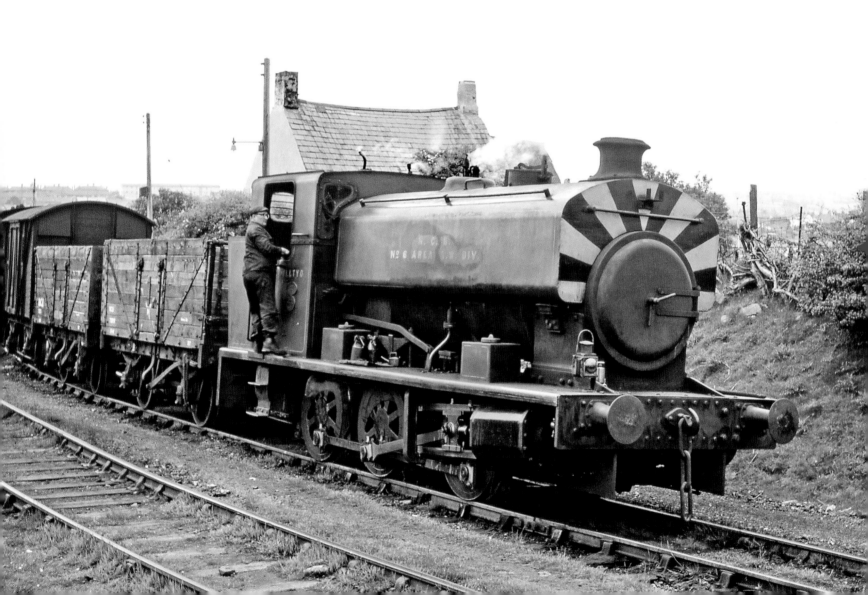

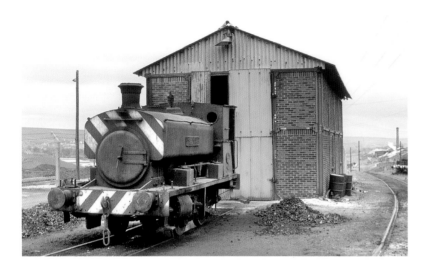

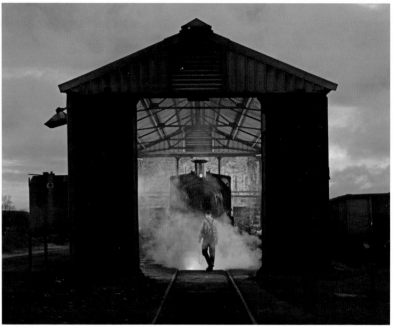

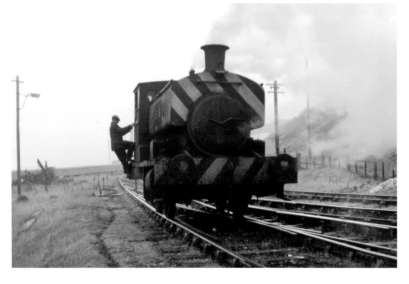

Above left: Moving back up the valley again to Blaenavon, *Blaenavon Nora No. 5* stands outside its shed on 21 May 1976, a structure which survives today, as does a prominent concrete slurry tower located nearby. (John Brooks)

Above: A 'before and after' comparison; the splendid original, although re-roofed, NCB loco shed at Blaenavon at dawn on 13 January 2019, with P&BR resident William Bagnall 0-6-0 saddle tank *Empress* (W/No. 3061 of 1954) raising steam pressure prior to its day's work. (Author)

Left: On 6 September 1972, at the throat of the yard leading to Big Pit colliery, the runner of Andrew Barclay 0-4-0 saddle tank *Blaenavon Toto No. 6* (W/No. 1619 of 1919) climbs aboard, taking refuge out of the rain. The belt conveyor from Big Pit colliery to Forgeside is in the background. (John Sloane)

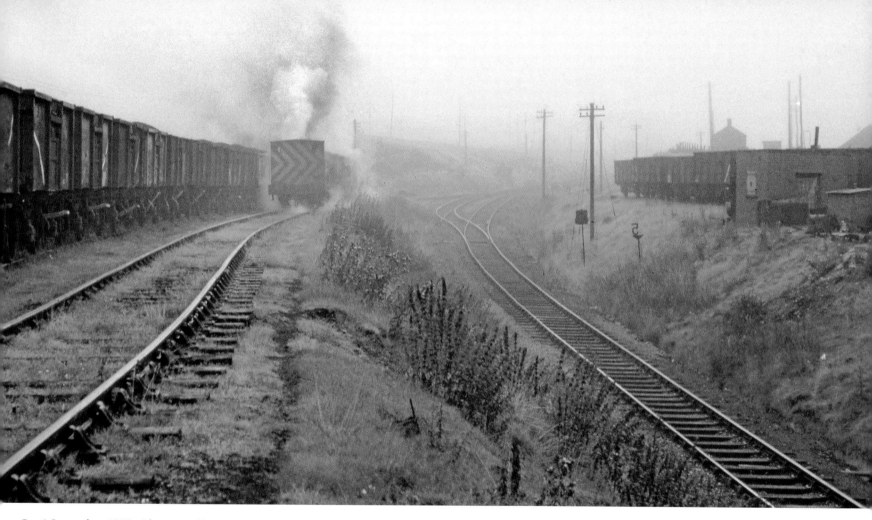

On 6 September 1972, *Blaenavon Toto No. 6* attempts to get its short rake of wagons on the move near Blaenavon washery, on the line leading to Big Pit colliery. The heritage P&BR is now based on this site and, as illustrated on the front cover of this book, the track layout remains much the same as it did then. The steeply graded single track on the right of the picture was the BR (ex-LNWR) line that is now the P&BR's main running line to Forgeside, and the formation on the left is now the single-track line serving Big Pit station. (John Sloane)

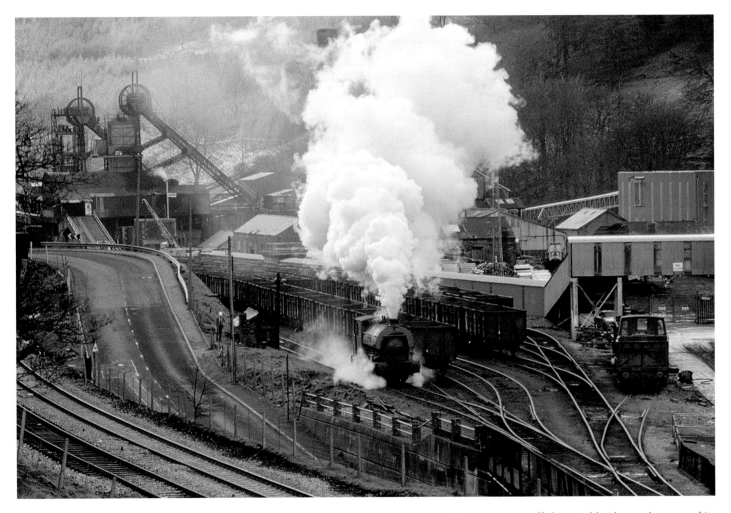

On 6 April 1983, Marine colliery's B3 class Peckett 0-6-0 saddle tank *Menelaus* (W/No. 1889 of 1934) moves off the weighbridge at the start of its working day. Affectionately referred to as 'Billy' by the colliery staff, by this time it was held in reserve to diesel traction, and often steamed during school holidays, allegedly for the benefit of the manager's children. (John Brooks)

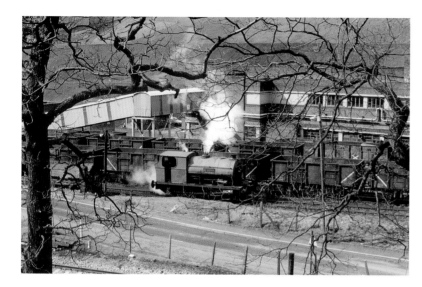

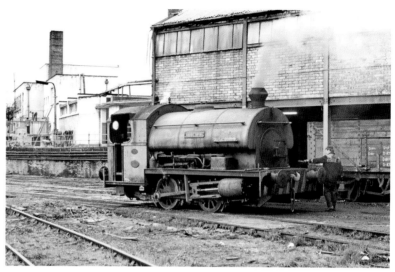

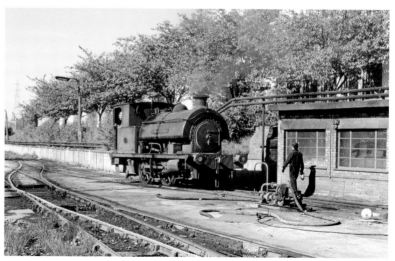

Above: On 6 April 1983, *Menelaus* rested much of the day by the Marine colliery weighbridge, due to low traffic levels. The colliery, located near Cwm and opened in 1891, was the last in Wales to employ steam traction. (John Brooks)

Above right: Peckett 0-4-0 saddle tank *Hornet* (W/No. 1935 of 1937) at Bersham colliery on 21 April 1978, one of two steam locos there at that time. This small but productive colliery to the south-west of Wrexham and adjacent to BR's Chester to Shrewsbury line originally opened in the 1870s. Much of its production was consumed by the nearby Shotton steel works. (John Sloane)

Right: Hawthorn Leslie 0-4-0 saddle tank *Shakespeare* (W/No. 3072 of 1914) at Bersham on 26 May 1978, where it had served since 1928. It was scrapped in November 1980, shortly before the colliery was revamped to accept MGR trains. (John Sloane)

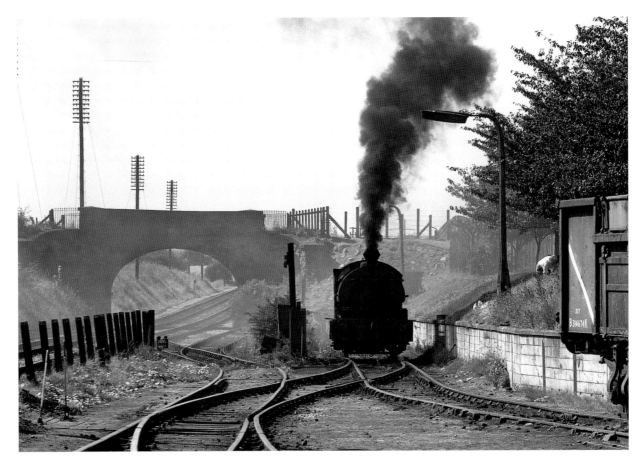

Above: W6 Special class Peckett *Hornet*, with its lowered footplate and cab roof, a necessity for negotiating a tight clearance on the line serving Black Park colliery, where it worked until 1951, was the favoured loco at Bersham. It is seen on 21 August 1972, brewing up in the headshunt alongside the BR line. Its distinctive chimney adornment was a fabrication added at Ifton colliery before it was moved to Bersham in 1968. (Richard Stevens)

Opposite page: *Hornet* alongside the BR line and loading screens at Bersham around the same period. It was regularly used until it was replaced by diesel traction in January 1980. The colliery closed in December 1986, its limited reserves proving to be no longer commercially viable. (Tony Brown)

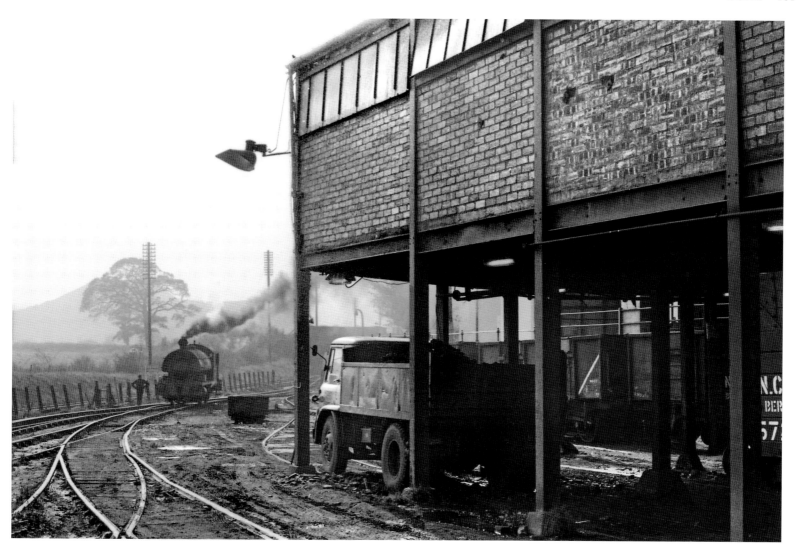

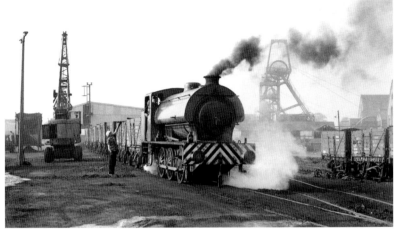

Above and opposite page: Gresford (Acton Grange) colliery was served by a short branch leading off the BR Chester–Shrewsbury line, 2 miles north-east of Wrexham, and was entirely steam-worked from its opening in 1911 until its closure in November 1973. In 1934, it was the scene of an appalling tragedy, an underground explosion resulting in the loss of 266 lives. In the early 1970s, this Robert Stephenson & Hawthorns Austerity (W/No. 7135 of 1944) was busy with internal wagons in the colliery yard. (Tony Brown)

Left: Viewed through the window of the loco shed at Gresford on 21 August 1972, Hudswell Clarke 0-6-0 tank *Richboro* (W/No. 1243 of 1917) was stored outside. Ostensibly a spare, it never saw use there after its arrival from Ifton in 1969. The former Inland Waterways & Docks loco, supplied new to Richborough in Kent, is now in the care of the Aln Valley Railway at Alnwick. (Richard Stevens)

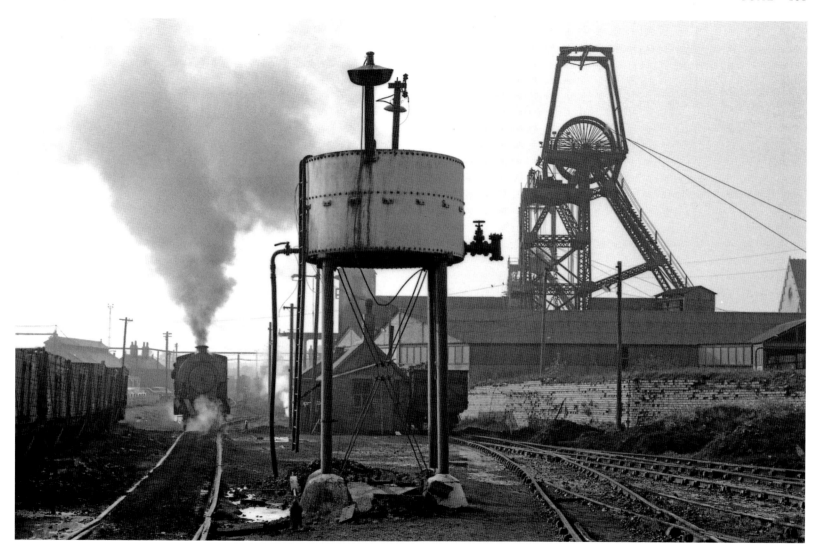

BY-PRODUCTS & CHEMICALS

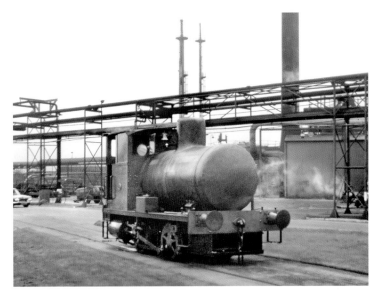

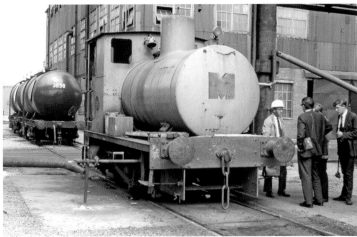

Above left: An Andrew Barclay 0-4-0 fireless (W/No. 2238 of 1948) at the Sully chemical works of BP Chemicals (UK) Ltd on 22 August 1970. The Barclay was supplied new to the works of British Resin Products Ltd, which had opened in 1946 and further expanded in 1950, served by the Barry Docks railway system. BP purchased the chemical and plastics interests of Distillers Co. Ltd in 1967. Despite a brief encounter with a four-coupled English Electric diesel-hydraulic loco in the early 1970s, which was soon transferred to the company's Baglan Bay works, the fireless remained in use right up until cessation of rail traffic at the works in 1986. It was presented to the National Museum of Wales, but it is currently not on public display, stored on the site of the former Nantgarw colliery. (Roy Burt)

Below left: Monsanto Chemicals Ltd's works at Newport enjoyed a rail connection with the East Usk branch line. Constructed on farmland in 1949, it manufactured industrial chemicals and plastics. During an Industrial Railway Society visit in 1969, Andrew Barclay 0-4-0 fireless 52/001 (W/No. 1966 of 1929) was at the steam charging point. It was acquired pre-owned for the opening of the works, from Reckitt & Colman at Norwich. Rail traffic ceased at the Monsanto plant in 1990 and, as the last regular working commercial industrial steam loco in Wales, it found a place in preservation, and is also in the Nantgarw store of the National Museum of Wales. (Author's collection)

Opposite page above left: Veteran Hudswell Clarke 0-6-0 saddle tank 10 (W/No. 544 of 1900) was a remarkable survivor in the 1970s, although the 'wasp stripes' on its cab and running plate sides were not entirely in keeping with its pedigree. By 24 August 1970, it had been set aside at Coed Ely Coking Plant. Delivered new to the Powell Duffryn Steam Coal Co. for use on their Aberaman Railways, its historical significance saw it survive into preservation and it is now on display at the National Museum of Wales at Big Pit. (Roy Burt)

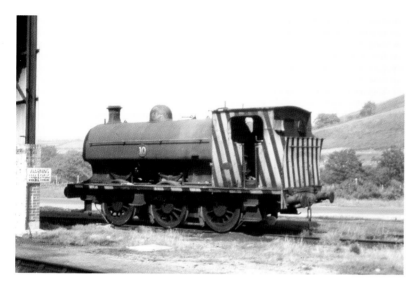

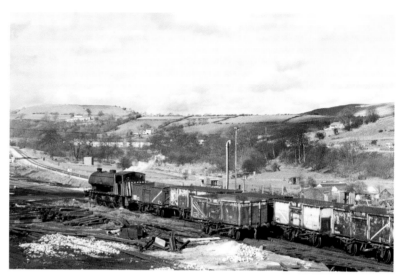

Above right: William Bagnall Austerity 0-6-0 saddle tank 75159 (W/No. 2747 of 1944) in the BR exchange sidings at Coed Ely Coking Plant, Tonyrefail, in the late 1960s. It was originally purchased by the NCB for use at Coed Ely colliery, having seen a brief period of service with the Belgian State Railways, based at Antwerp. It was cut up on site in December 1970, two ex-BR 03 Class locos (D2139 and D2178) having taken over shunting duties at the plant. (Author's collection)

Right: The Mond Nickel Co. Ltd founded a works at Clydach-on-Tawe in 1900, with siding connections to both the GWR Clydach branch and the Midland Railway line. On this 19 April 1991 visit, the works was owned by Inco Europe Ltd, where English Electric Vulcan Works 0-4-0 diesel-hydraulic C0120 (W/No. D1205 of 1967) was in use. A 1913-built Peckett 0-4-0 saddle tank had been retained at the site until just before this visit. (Author)

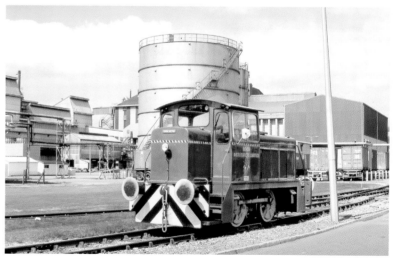

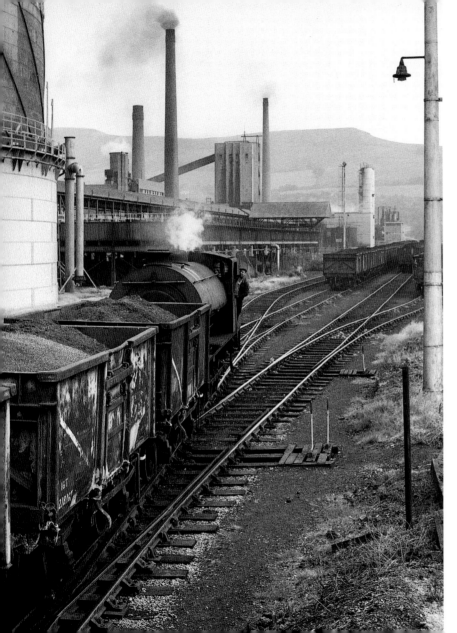

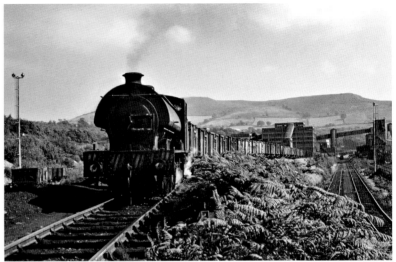

Left: Nantgarw Coking Plant was situated near Treforest, in the lower reaches of Taff Vale and was connected to the by then-truncated ex-Cardiff Railway line north of the site of Nantgarw Low Level halt. In the early 1970s, it had three Austerity 0-6-0 saddle tanks, of which two were generally steamed daily. During this visit on 6 September 1972, No. 3 (W/No. 3787 of 1953) was in action. (Richard Stevens)

Above: Hunslet Austerity No. 1 (W/No. 3767 of 1951) at Nantgarw on 4 September 1972. Steam was not to last, as diesels arrived three months later, and all three Austerities were scrapped on site during the following year. (John Sloane)

Opposite page: On 6 September 1972, Hunslet Austerity No. 3 makes its own contribution to the pollution that always surrounded such coking plants. Another Austerity was in steam in the shed at Nantgarw, and had probably seen use on the morning shift. (Richard Stevens)

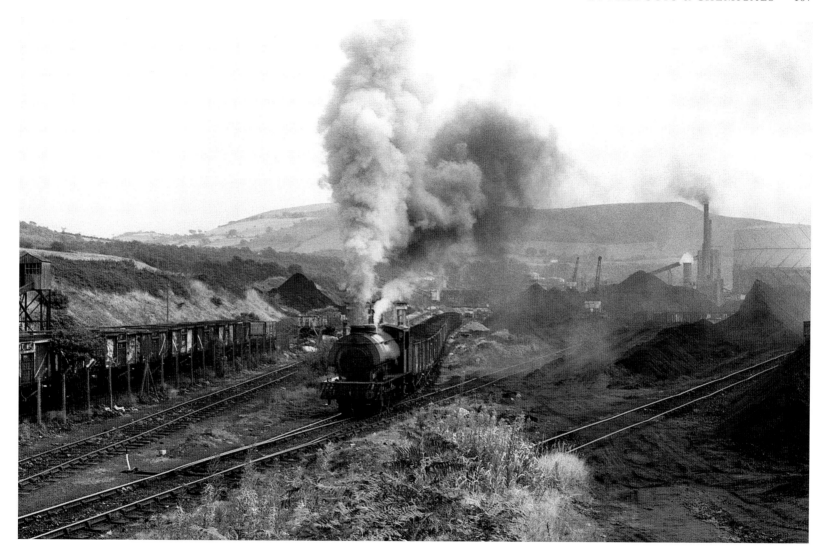

Above left: The locos which replaced the Austerities, former BR Class 11 Derby-built 0-6-0 diesel-electrics 12071, 12063 and 12061, stand out of use at the closed Nantgarw Coking Plant on 28 April 1987. (Roy Burt)

Above: Grange Coke Ovens were situated on the harbour side of Port Talbot steelworks. On 24 August 1970, Greenwood & Batley 0-4-0 wire-electric F (W/No. 2801 of 1958), one of nine employed there, stands attached to its coke car. (Roy Burt)

Left: Brush Bagnall Traction 400 hp 0-6-0 diesel-electric No. 1 (W/No. 3073 of 1955) at Cwm Coking Plant & Colliery, Llantwit Fardre, on 24 August 1970. The complex closed in November 1986 and this and two other diesels were scrapped on site in 1987. (Roy Burt)

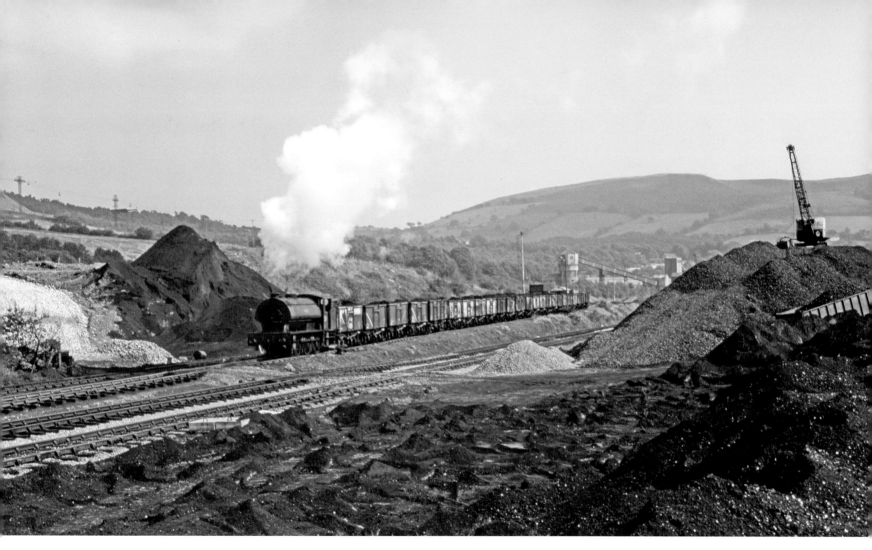

Hunslet Austerity No. 1 at Nantgarw Coking Plant on 4 September 1972, during the last weeks of steam activity there. The reign of the diesel lasted for just twelve years, the plant suffering closure in November 1986. (John Sloane)

8

ROYAL NAVAL
ARMAMENT
DEPOT (RNAD) TRECWN

Opposite page: The RNAD at Trecwn in Pembrokeshire was first opened to traffic in September 1938 and was connected by a 2½-mile branch with the GWR at Letterston Junction, where extensive exchange sidings were located. The depot comprised numerous dispersed bunkers and buildings both above and below ground, including stores, workshops, laboratories and product transhipment sheds, extending along a naturally secluded valley for around 2 miles. In addition to the standard gauge, there were around 30 miles of 2 ft 6 in. gauge lines, much of which served underground bunkers. GWR workmen's services served the depot during the Second World War. Heightened by Cold War tensions, these were reinstated by BR, operating to and from Goodwick between May 1950 and April 1965. Internal passenger trains also served various parts of the depot; the narrow gauge services were replaced by buses in 1979 and on the standard gauge in 1982. Shunting the exchange sidings at Trecwn on 27 June 1984 was North British 275 hp 0-4-0 diesel hydraulic 413 (W/No. 27648 of 1959). It had been drafted in from the Army Department at Bramley in June 1982, and upon closure of the Trecwn facility, it was in turn transferred to MoD Long Marston for further work. (Roy Burt)

Above right: Most of the loco fleet was held on the books of the Ministry of Defence, but the railway infrastructure was the responsibility of the Ministry of Public Building & Works (Department of the Environment) which, up until around 1983, retained two locos exclusively for permanent way work and maintenance purposes. The original narrow gauge Hunslet loco fleet comprised two 23 hp and fourteen 50 hp four-coupled diesel-mechanical locos, supplemented by nine small battery-electric locos of Wingrove & Rogers and Greenwood & Batley manufacture, plus a Frank Hibberd passenger diesel railcar. A fleet of twelve new diesel-mechanical locos, six each of 70 hp and 99 hp, were supplied by Baguley-Drewry between 1980 and 1984. These replaced most of the ageing Hunslet locos, although five were retained and worked alongside the Baguley-Drewry locos into the 1990s. Following easing of Cold War tensions, the depot was gradually scaled down, until its final closure came about in 1994. On 20 August 1994, 2 ft 6 in. gauge 99 hp Baguley Drewry four-wheel diesel-hydraulic ND10557 (W/No. 3782 of 1983) stands attached to a varied rake of wagons, including a fork-lift truck carrier. The transfer of stores and explosives was handled in bunkers around various parts of the site by fork-lift trucks, redeployed about the site as required on such bespoke wagons. (Author)

Below right: Shortly before their disposal, Baguley-Drewry four-wheel diesel-hydraulic locos (W/Nos 3780 and 3783 of 1983) rest inside the RNAD loco shed on 20 August 1994. (Author)

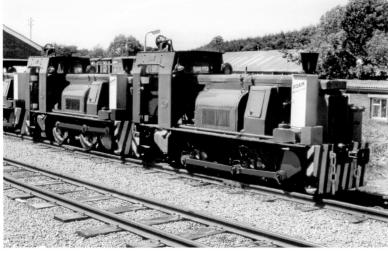

Above left: Hunslet 77 hp 0-4-0 diesel-mechanical *Yard No. 3068* (W/No. 2392 of 1939) with a 'for internal use only' brake van in the RNAD standard gauge sidings on 27 June 1984. (Roy Burt)

Above: The unique Frank Hibberd four-wheel diesel-mechanical personnel carrier railcar, *Yard No. B54* (W/No. 2196 of 1940), and a four-wheel van at Trecwn on 27 June 1984. (Roy Burt)

Left: Despite their age, the forty-year-old 50 hp Hunslet 0-4-0 diesel-mechanical locos were immaculately maintained. On this June 1984 visit, *Yard No. 3062* (W/No. 2400 of 1941) and *Yard No. 3061* (W/No. 2399 of 1941) stand outside the RNAD narrow gauge loco shed.

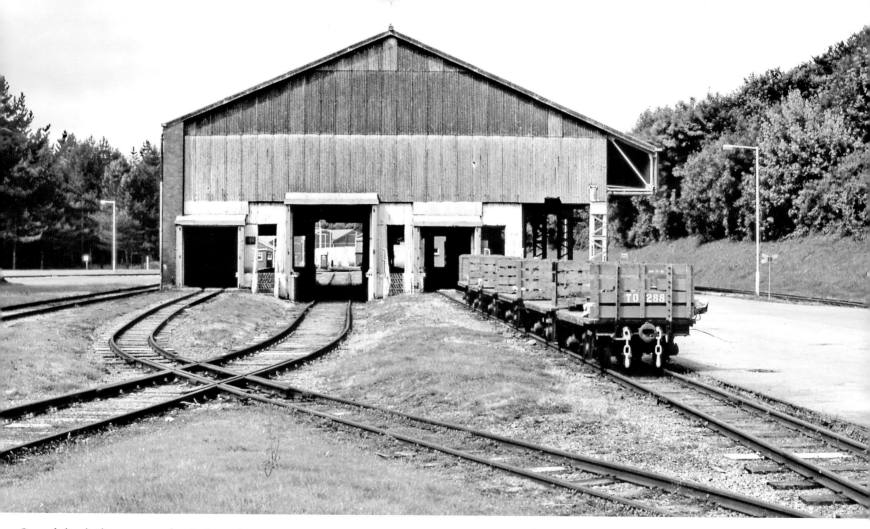

One of the dual gauge transfer sheds at the RNAD, with a crossover in the foreground. By this 20 August 1994 visit, the armament depot had ceased functioning and clearly the railway had not seen use for some time. The defunct real estate was to be sold off shortly after this, with all rolling stock and locos disposed of by auction. Most of the exceptionally well-maintained narrow gauge locos unsurprisingly found new homes in preservation. (Author)

9

INDUSTRIAL

MISCELLANY

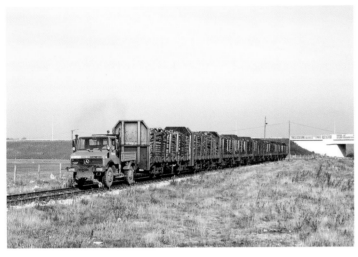

Above left: If there were any doubts over the capability of a humble Mercedes Benz Unimog road-rail vehicle, this photo dispels them! On 12 October 1990, Shotton Paper Plc's vehicle was giving all the power it possessed, drawing a rake of nine laden bogie timber wagons up the grade from the BR exchange sidings, passing beneath the then new A548 Weighbridge Road, just north of Shotton steel works. (Author)

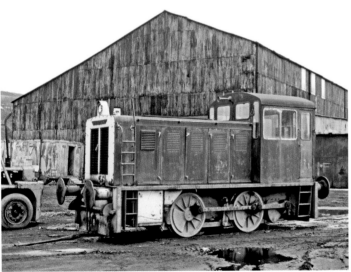

Below left: A North British 225 hp 0-4-0 diesel-hydraulic (W/No. 28038 of 1961) dumped out of use at Neath Cargo Terminal, Briton Ferry, on 21 April 1990. Supplied new to Cadbury Schweppes at Bourneville, it received an appropriate chocolate and yellow livery, but the salt-laden sea air had clearly taken its toll over the fourteen years it had spent at Giant's Grave, an appropriately named yard where former ocean-going vessels were cut up. North British supplied a large batch of this design to replace steam locos in industry, especially to the NCB. This loco was similar in appearance to the BR D27XX Class, and was part of an order fulfilled immediately following the BR production series, the final BR loco being No. D2780 (W/No. 28033), delivered in 1961. (Author)

Opposite page: Hudswell Clarke 0-6-0 diesel-mechanical *Pride of Gwent* (W/No. D1186 of 1959) at the Newport Coal Distribution Depot of Gwent Coal on 20 April 1990, with the new A48 ring road then under construction. The Newport Transporter Bridge spanning the River Usk looms in the background. It was accorded Grade I listed status on account of its historical importance and unusual design; there are only two others like it in the UK and seven in the world. Celebrating its centenary in September 2006, it is in the care of Newport City Council. The Hudswell Clarke diesel, originally a member of the Manchester Ship Canal railway fleet as D1 *Ashdown*, is now kept at Darley Dale, near Matlock, part of the Andrew Briddon collection of locos. The railway and coal depot no longer exist, swallowed up by the A48. (Author)

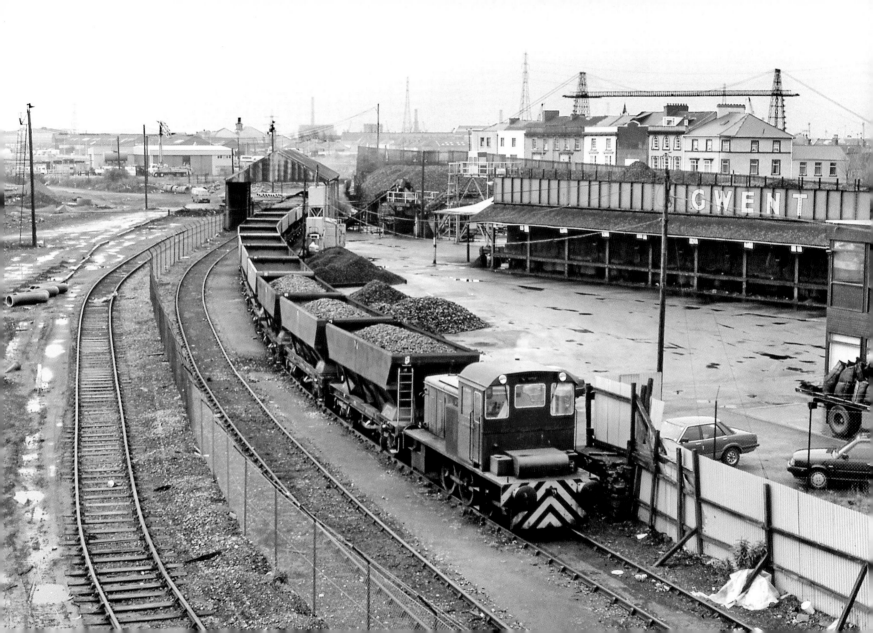

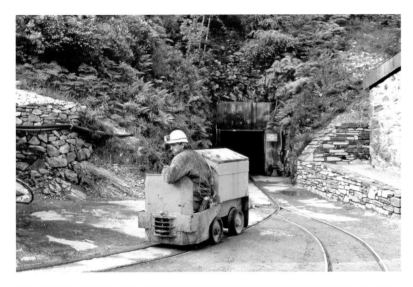

Above left: 1 ft 10½ in. gauge four-wheel battery-electric locomotive built by NEI Mining Clayton Equipment (W/No. B29441 of 1982), emerging from the mine adit at Welsh Gold, Gwynfynnydd & Beddcoed Gold Mine, Coed-y-Brenin, near Dolgellau on 19 August 1994. Welsh gold has been mined since at least the Bronze Age, and the purity of the gold greatly encouraged its extraction. The Romans certainly valued it above other sources of gold, perhaps because it possesses a reddish tint in comparison to gold extracted elsewhere, stained by copper which lies in the rock adjoining the veins of gold. Although there is no evidence for gold mining taking place at Coed-y-Brenin in the time of Rhiannon and Geraint there are certainly rich veins of gold there, and gold would have been visible in the rivers and streams. The Gwynfynnydd Gold Mine was closed in the late 1990s and today there is now only one active gold mine in Wales. This is the Dolaucothi Gold Mines near Pumpsaint in Carmarthenshire, a listed ancient monument in the hands of the National Trust, where this diminutive battery loco can now be found. (Author)

Below left: This standard gauge Motor Rail four-wheel diesel-mechanical (W/No. 1944 of 1920), neglected and virtually forgotten, with nature taking over, is seen at a privately owned site near Mold in May 2015. This rare ninety-five-year-old survivor was used until March 1983 at the nearby Mold Synthite Works, located on the freight-only stub of the former Mold & Denbigh Junction Railway, which had closed to passengers in 1962, with rail traffic ceasing in 1983. The Alyn works at Mold had originally served as a cotton mill (1792 – *c*. 1866), a tinplate works (1874–1943), a Ministry of Supply store depot (1943–46), and finally the Synthite chemical works manufacturing formaldehyde from 1950 until the present day. Motor Rail & Tramcar Co. Ltd rebuilt many former War Department Light Railway (WDLR) 60 cm gauge Simplex armour-plated locos when they became surplus to the requirements of the War Department, many having previously worked overseas on the WDLR systems. The heavy armour plating was retained, deemed to be useful for providing ballast for railhead traction as well as offering some protection from the elements for the driver, instead of the bullets and shrapnel for which they were originally designed! New frames and standard gauge running gear were added to offer a low-cost post-war standard gauge shunting loco, affectionately known as 'Tin Turtles'. This rebuilt example was originally sold to Flint Paper Mill, Oakenholt, in December 1919. The petrol engine was replaced in 1959 with a Dorman 40 hp diesel engine. It was sold on to the Alyn Works of Synthite Ltd in August 1965 and replaced an identical Simplex loco, originally Lancashire & Yorkshire Railway works shunter No. 3 (W/No. 2033 of 1920). (Author)

Right: Up until 1990, peat had been harvested for around a century from a large area of natural bog-land on Whixall and Fenn's Moss, south-west of Whitchurch. The 2 ft gauge tramway on the Fenn's Bank system acquired its first loco in 1919, a new 'bow-frame' Motor Rail Simplex. As the workings expanded through the 1920s, a new mill was established at Bettisfield, which had a private siding with the Cambrian Railway. An additional new four-wheel petrol-mechanical 'bow-frame' Simplex was delivered in 1926 and these two locos were the mainstay of operations until two pre-owned Ruston & Hornsby locos arrived in the late 1960s. By 1971 the tramways had been replaced by tractor and trailer, extractions then being concentrated on the east side of the moss. On 20 March 1976, this Motor Rail (W/No. 4023 of 1926), fitted in 1967 with a 22 hp Armstrong Siddeley diesel engine, was dumped out of use, where it would remain until rescued for preservation in November 1990. It is now at the Hampton & Kempton Waterworks Railway at Hanworth, Greater London. (Roy Burt)

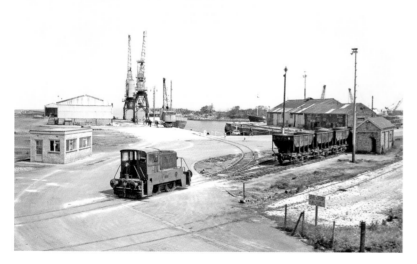

Left: Yorkshire Engine Company 220 hp 0-4-0 diesel-electric 2 (W/No. 2819 of 1960) working on the internal system of Mostyn Docks Ltd in the mid-1980s. Supplied new to work the docks railway, then owned by Barrow Haematite Steel Co. Ltd, it was one of two such locos of the same design and constructed on the same production line as the BR 02 Class locos. The three delivered to Mostyn replaced an operational fleet of five four-coupled Hunslet and Hudswell Clarke steam locos. The 21-ton hopper wagons would probably be waiting to be loaded with raw sulphur, for the occasional on-demand flow to the Associated Octel factory at Amlwch on the Isle of Anglesey. Other commodities handled at the docks and moved by rail at this time were acetic acid and timber. Regular rail operations came to an end at the port in 2008, with the cessation of steel movements; however, the strategic Network Rail connection has been retained in the hope of traffic returning in the future. (Author's collection)

SERVICE AFTER THE
MAIN LINE

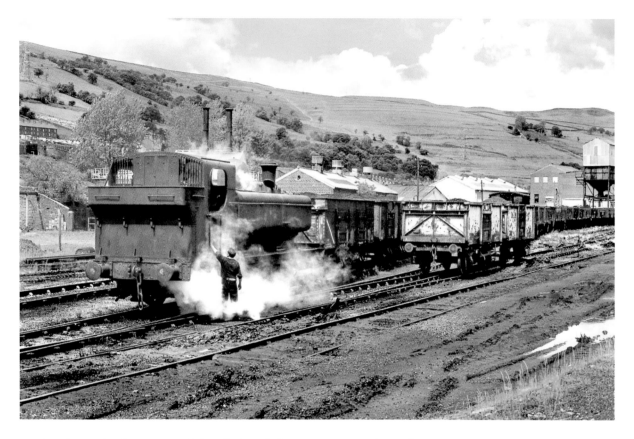

Several former main line locos, both steam and diesel, found their way into industrial service in South Wales, many of the diesel examples having experienced a relatively short career with BR. Unsurprisingly, BR pannier tanks were an obvious choice as they became surplus, and a small number found their way to the Welsh Valleys instead of the scrapyard.

Above and opposite page: On 28 June 1972, Swindon 1945-built No. 9600 was preparing to take a loaded train to the BR exchange sidings from Merthyr Vale colliery, one of the largest pits in the South Wales Valleys and sunk as early as 1869. Its spoil tips were on the hill above Aberfan and tragically avalanched down onto part of the town on 21 October 1966. The colliery was closed on 25 August 1989. (Both author)

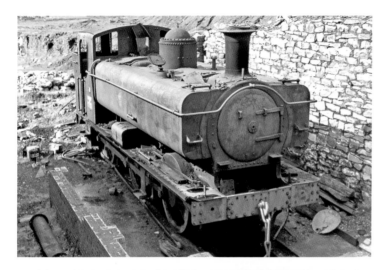

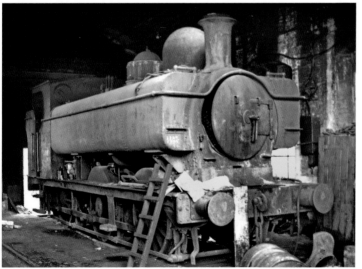

During early 1959, NCB representatives visited BR Swindon Works with a view to acquiring some surplus pannier tank locos and they initially agreed to purchase Collett 5700 Class Nos 7714 and 7754, as well as Hawksworth 1600 Class No. 1607, all for use in South Wales, but these were soon followed by six more 5700 Class locos, Nos 3650, 3663, 9629, 9642 and 9792, with finally No. 9600 completing the order by October 1965.

Above left: On 28 June 1972, Swindon 1936-built 5700 Class pannier tank No. 9792 was dumped alongside the Mardy colliery loco shed. Withdrawn from Neath depot in March 1964, and immediately acquired by the NCB, it spent a short time on the Aberaman Railways before transfer to Mardy colliery. Unlike sister loco No. 9600 at Merthyr Vale, which saw a further eight years of successful commercial post-BR service, No. 9792's reign proved to be short-lived. As *Mardy No. 4*, it was not a popular loco there. After languishing in open storage from Autumn 1970, it was dispatched for scrap in September 1973. (Author)

Below left: Another pannier tank to see further post-BR service was Collett 5700 Class No. 7714 (Kerr Stuart W/No. 4449 of 1930). It was a newcomer to the South Wales Valleys when acquired by the NCB in July 1959, for it had previously seen service at Tyseley, Birkenhead and finally Wrexham Rhosddu depot, before withdrawal in January 1959. Put to work at Penallta colliery, near Ystrad Mynach, it saw limited use due to the unsuitability of its long wheelbase for the colliery track layout. It was relegated to a reserve loco for the resident Austerity saddle tank and a new English Electric diesel-hydraulic, delivered in 1964. On 28 June 1972, No. 7714 was found in a dilapidated condition languishing inside the dark, soot-encrusted loco shed at Penallta, but still displaying remnants of a maroon livery not too dissimilar to its London Transport counterparts. Despite its condition, it survived into preservation and was moved to the Severn Valley Railway during the following year. It steamed again in 1992 after a protracted overhaul and has since been a regular performer on the railway. (Author)

Opposite page: Sunrays beam down through the roof of Mountain Ash loco shed on 28 June 1972, with No. 7754 (North British W/No. 24042 of 1930) languishing inside. Acquired by the NCB in July 1959 following withdrawal from BR Wellington loco shed, it saw service at Windsor, Llanbradach, Ogilvie and Elliot collieries, before transfer to the Talywain Railway at Abersychan where, during 1969–70, it was used on the workmen's train to Blaenserchan colliery, before a transfer to Mountain Ash in May 1970. By 1976, it had seen its final service with the NCB as the last 5700 Class in commercial use, but it was rescued for preservation by the Llangollen Railway. (Author)

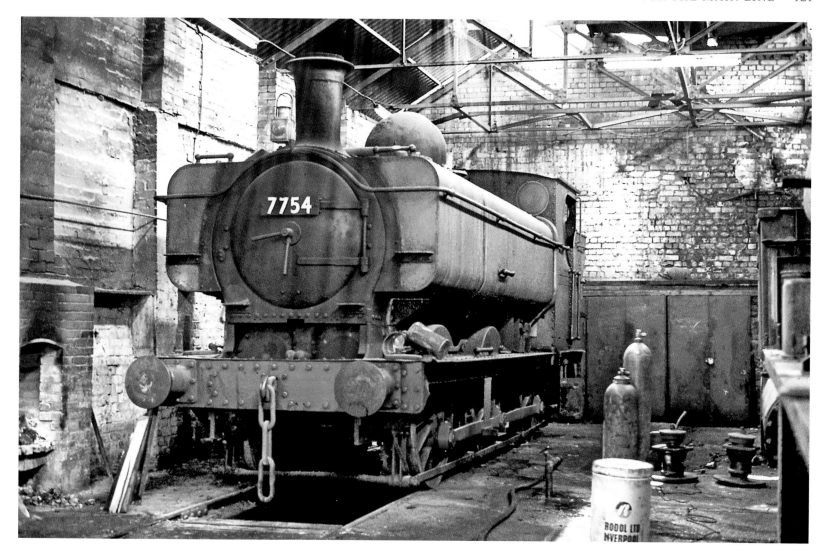

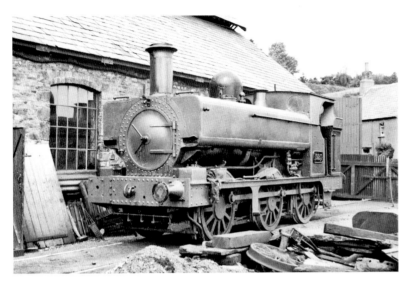

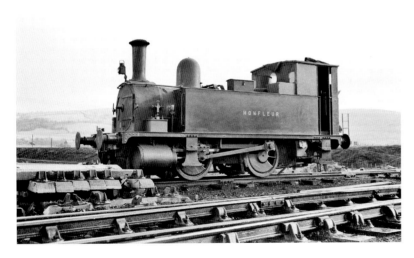

Above left: Former GWR Wolverhampton works 1882-built 0-6-0 pannier tank No. 1923 at the Maesteg Railways loco shed on 8 June 1954. Purchased from the GWR in September 1939 by the Ocean & United National Collieries Ltd, it served at Treorchy, Garw and Maesteg, before meeting its fate at Penllwyngwent colliery by June 1959. (Doug Clayton – IRS collection)

Above right: Former Great Eastern Railway four-coupled 'piano tank' No. 0229 (Nielson 2119 of 1876) at the yard of Fairfield-Mabey Ltd at Chepstow (originally Admiralty National Shipyard No. 1) on 4 September 1972. (John Sloane)

Left: Adams Nine Elms 1893-built B4 Class dock shunter No. 95 *Honfleur* was sold out of BR service in May 1949 and put to work at the newly established Wernos Disposal Point at Ammanford, before being transferred to the NCB Opencast Executive's new Gwaen-cae-Gurwen Disposal Point in the early 1950s, where it was photographed. It was scrapped during 1957. (Kevin Lane collection)

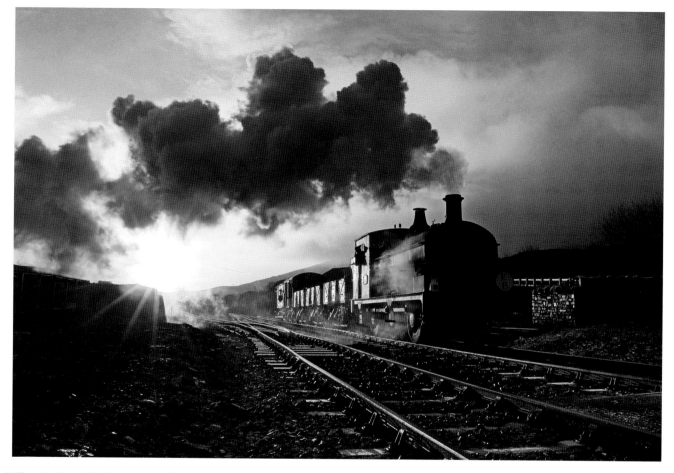

Former Port Talbot Railway/GWR 0-6-0 saddle tank No. 813 (Hudswell Clarke W/No. 555 of 1900) in action on the heritage P&BR at sunrise on 12 January 2008 during its temporary visit masquerading as Robert Stephenson 1898-built sister No. 816, which saw post-GWR service on the nearby Talywain Railways until scrapped by the NCB by June 1954. The P&BR's infrastructure is of course of both industrial and main line pedigree. Following its sale by the GWR in 1933, No. 813 saw NCB service at Backworth in Northumberland until its withdrawal from service in 1967. It is now maintained on the Severn Valley Railway. (Author)

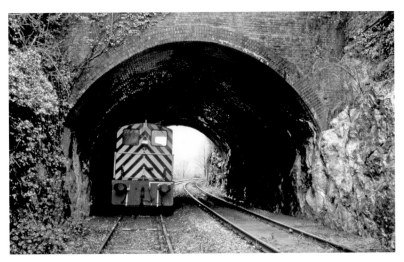

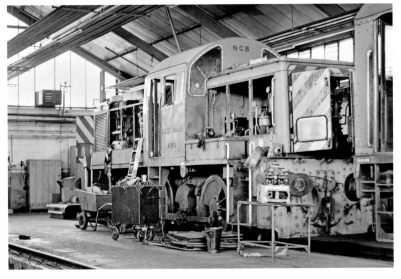

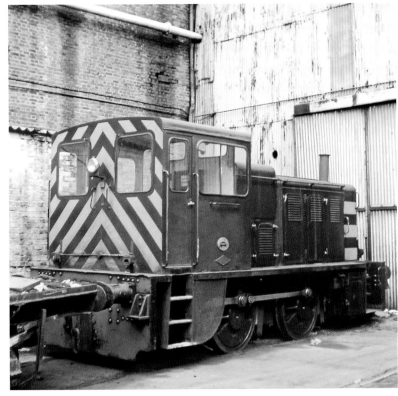

Above left: In April 2001, ex-BR Swindon-built Harry Needle hire loco 03 Class No. D2199 stands adjacent to the ARC Machen loading point inside the tunnel of the former Brecon & Merthyr Railway's Bedwas branch, which served Bedwas Navigation colliery until its closure in 1985. The 204 hp loco entered BR service in June 1961 and was withdrawn from Barrow-in-Furness depot in June 1972, before receiving a TOPS number. It was sold to the NCB in South Yorkshire and was later acquired by Harry Needle. It remained at Machen until 2006 and is now with the Heritage Shunters Trust at Rowsley South. (Author)

Opposite page below left: Newport dealer A. R. Adams & Son specialised in surplus BR locos, either used on hire contracts or sold on into industry. The 650 hp Class 14 0-6-0 diesel-hydraulic No. D9530, a BR type previously familiar in South Wales albeit briefly, was purchased by Adams from the Gulf Oil Refinery at Waterston, where it had been used since September 1969. It was sold on to the NCB at Mardy colliery in October 1975. Evidently not too successful, it was dispatched twice for repair to BR Newport Ebbw Junction and Canton depots under an NCB/BR agreement, and was photographed at the former depot on 18 July 1976. It was scrapped at Mardy colliery in April 1982. (John Sloane).

Opposite page above right: Former BR Eastfield-allocated North British 225 hp 0-4-0 diesel-hydraulic No. D2763 (W/No. 28016 of 1960) at BSC Landore Foundry on 26 August 1970. It arrived there during summer 1969 after overhaul at Andrew Barclay's Kilmarnock works, and was scrapped in April 1977. The only other example of this BR class to spend time in South Wales post-BR service was No. D2774, sold in March 1971 via Andrew Barclay to the NCB at Celynen North colliery. No. D2774 eventually moved into preservation at the East Lancashire Railway in 1986. North British also supplied similar 225 hp locos directly to the NCB in South Wales (see page 90). (Roy Burt)

Above right: In July 1968, the Llanelly Steel Co. Ltd purchased four former BR Drewry 204 hp 04 Class locos (Nos D2304–D2307) via South Yorkshire dealer R. E. Trem & Co. Ltd to replace the surviving members of the steam fleet at their Llanelli works (see page 29). One further example, No. D2308, arrived some ten years later from the Briton Ferry steel works, both works by then being in the ownership of Duport Steels Ltd. On 18 July 1976, one of the original batch of four, the former No. D2304, bearing the works fleet number D8 (Robert Stephenson & Hawthorns W/No. 8163 – Drewry Car Co. W/No. 2685 of 1960), had seen its last working days and was awaiting the cutter's torch, along with the sorry remains of John Fowler 40 hp 0-4-0 diesel-mechanical (W/No. 22488 of 1939) and Ruston & Hornsby 48DS Class (W/No. 525920 of 1967). (John Sloane)

Below right: The Briton Ferry Steel Co. Ltd had a penchant for surplus BR shunters, acquiring both Drewry 04 Class and Hunslet 05 Class examples. On 26 August 1970, former BR 04 Class No. D2340 was at work at the Albion Steel Works at Briton Ferry, still in its full BR green livery. The former BR Bradford (Manningham) shunter, acquired from BR in April 1969, was scrapped during late 1979 shortly after steel making had ceased at this open hearth plant. (Roy Burt)

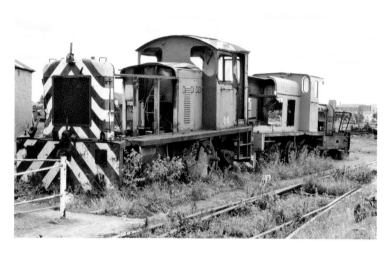

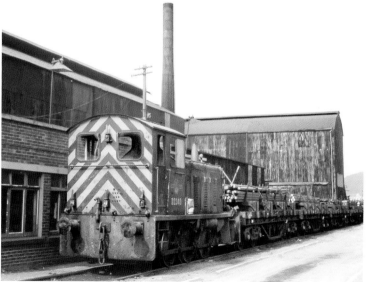

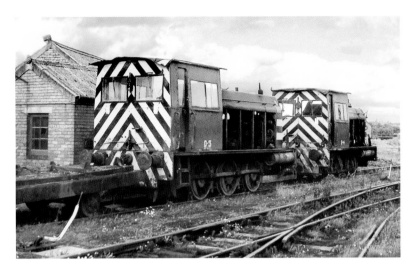

Above left: Two Hunslet locos at the Llanelly Steel Works on 16 August 1970 – former BR Wigan (Springs Branch) depot 204 hp 0-6-0 diesel-mechanical No. D2561, bearing the Llanelly Steel Works fleet number D3 (W/No. 4999 of 1957) and acquired from BR in March 1968, makes an interesting comparison with former BR 153 hp 01 Class 0-4-0 diesel-mechanical No. D2950, bearing works fleet number D4 (W/No. 4625 of 1954), latterly a Goole-allocated shunter purchased by dealer R. E. Trem and sold on to the Llanelli works in May 1968. D3 (ex-BR No. D2561) was scrapped in October 1972, but could well have provided spares for sister loco D5 (ex-BR No. D2601) also at the works, which survived until 1979. The former BR No. D2950 saw further use and was purchased by civil engineering contractor Thyssen (Great Britain) Ltd in summer 1980, but was cut up on site during the winter of 1982/83, its engine subsequently being used in a trawler. (Roy Burt)

Below left: Cut-down Clayton 9.5 hp four-wheel diesel-hydraulic (W/No. 5632 of 1969) was one of three specialist locos purchased by the Llanelly Steel Co. Ltd for the melting shop duties, previously the preserve of the four cut-down Andrew Barclay 0-4-0 saddle tanks (see pages 29 & 31). The Clayton is seen with the former BR No. D2950 on 18 July 1976, the steel works by then in the ownership of Duport Steels Ltd. Since 1896, the works had produced special steels for tinplate manufacture and the company was never nationalised. In 1949 a new rolling mill for bars, billets and slabs was installed, and in 1977 two large electric arc furnaces replaced the nine open hearth furnaces. Duport Ltd was a victim of the trade recession shortly thereafter, and their Llanelli works was sadly closed in 1981. (John Sloane)

Opposite page: The loco shed at the Briton Ferry Steel Co. Ltd's Albion Works on 26 August 1970, with former BR 05 Class No. D2600 (Hunslet W/No. 5649 of 1960) and BR 04 Class No. D2247 (Drewry Car Co. W/No. 2579 – Robert Stephenson & Hawthorns Newcastle W/No. 7866 of 1956). The steel works, opened in 1895, was located on the south-east side of Briton Ferry dock and produced steel for tinplate and general engineering. By the time of this visit, the open hearth steel plant had five active furnaces, but the rolling mills ceased production shortly thereafter, with steel making coming to an end in 1978. Since 1960 the owning group, Duport Ltd, would have had an influence over acquisition of the assets for both the Llanelli and Briton Ferry steel works, so it is logical that some of BR's surplus 04 and 05 Class locos, then obtainable at an attractive price in the late 1960s, were represented at both of these plants. (Roy Burt)

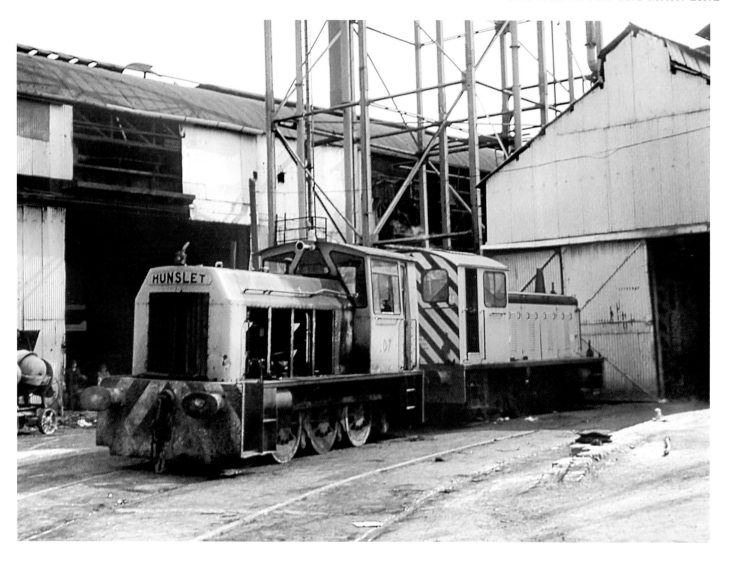

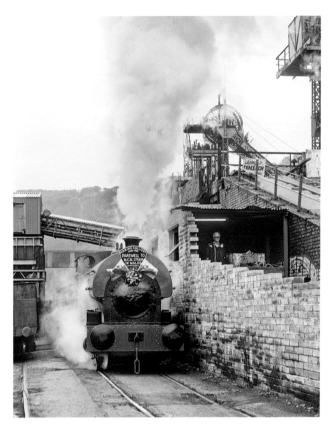
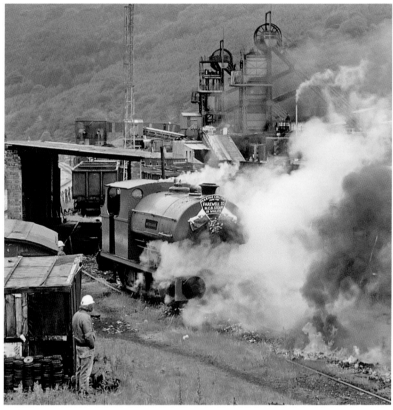

And finally, although regular commercial conventional industrial steam activity had ceased in Britain in October 1983, there was to be one final hurrah, at Marine colliery on 28 June 1985. Some running repairs had been carried out on Peckett *Menelaus* and she had been repainted prior to what was planned to be a series of 'final steaming days', after which she would pass into preservation. She was adorned with a commemorative headboard and flags to mark the event. During the morning, *Menelaus* was seen (left) working loaded wagons past the Marine colliery pit head. Rapid loading bunkers for merry-go-round wagons were in the process of being installed, with much of the older infrastructure being demolished to make way for the new equipment. Sadly, the day did not end as planned, for during the early afternoon *Menelaus* blew a mud hole door joint and (right) had to be rapidly retired to the loco shed, with the contents of her firebox being ejected onto the track along the way. This ignominious event, recorded by just a few, brought the curtain down on NCB steam activity in Britain, leaving just a handful of fireless locos still in service in industry. Despite its upgrade, Marine colliery remained operational for just four more years, the last coal being wound there in March 1989. (Both John Brooks)